CAMBRIDGESHIRE
THROUGH TIME
Michael Rouse

BRADWELL
BOOKS

Acknowledgements

My thanks to the Cambridgeshire Collection at the Central Library, Cambridge, for the use of the following photographs: 15, 16, 22, 28, 34, 36, 38, 42, 45, 47, 49, 50, 51, 52, 53, 54, 56, 57, 60, 61, 67, 69, 75, 76, 87, 88, 89, 91, 92, 93 and 95; and to Footsteps for the photographs of Fordham Market Street (13) and Kirtling post office (30). The photograph of Kennett station was by Douglas Thompson and distributed by Robert Humm & Co. of Stamford. Thanks to the Planning Department at South Cambridgeshire District Council, Allison Conder and all those who have given me directions or answered questions as I have gone about the county. I have referred to numerous village websites and Robert Stevens' *Cambridgeshire Windmills and Watermills*.

My thanks to Lauren Newby and all at Amberley for giving me the opportunity to explore once again some delightful old villages.

First published in 2012 by
Amberley Publishing for Bradwell Books

Amberley Publishing
The Hill, Stroud, Gloucestershire, GL5 4EP
www.amberley-books.com

Copyright © Michael Rouse, 2012

The right of Michael Rouse to be identified as the Author of this work has been asserted in accordance with the Copyrights, Designs and Patents Act 1988.

ISBN 978 1 4456 0718 4

British Library Cataloguing in Publication Data.
A catalogue record for this book is available from the British Library.

Typesetting by Amberley Publishing.
Printed in Great Britain.

Introduction

Cambridgeshire is a large county with a great number of villages, so this book concentrates on the villages of Cambridgeshire before the 1974 reform of local government, that is before the amalgamation with Huntingdonshire. It is not possible to include every village and this volume takes a clockwise tour around the county, but not Cambridge itself. It is a journey along the Fen Edge and into those villages like Ashley and Cheveley on the Suffolk borders, through the studlands around Newmarket, with the colour-washed, thatched cottages and flint walls, down to that prettiest of corners with the beautifully kept Balsham and the ancient houses of Linton. The old county bordered Essex and Hertfordshire, close to Royston, the old Huntingdonshire at Gamlingay and the Papworths back to the Fen Edge with Fen Drayton, Rampton and Histon.

This has been something of a sentimental journey for me. In the early 1970s, John Venmore Rowland asked me to write *A View into Cambridgeshire* for Terence Dalton Ltd. I visited most of the villages with my camera and I have used photographs I took then in this book. It was gratifying to find many of the scenes still instantly recognisable and old pubs I saw then, like the George at Babraham, the Golden Ball at Boxworth, the Red Lion at Whittlesford and the Royal Oak at Barrington, all still very much in business. Since that book was written, I sense on these recent visits a greater prosperity, despite these challenging economic times. Papworth Everard has changed hugely over the intervening years, with a new village centre and some impressive housing; Bar Hill has become established and there is the new settlement of Cambourne. The guided busway is new between St Ives and Cambridge and I caught it gliding through the old Oakington Westwick railway station.

Busy major highways like the M11, A11, A428 and the A14 now slash through the old county, and many of the villages have been bypassed.

To appreciate Cambridgeshire, it is essential to turn off the fast main roads and discover the villages. These are the heart of the county, full of interest, history and pride in their appearance. There is a wealth of thatched cottages, ancient churches, water mills, superb inns offering quality food and glorious views of rolling countryside as the East Anglian Heights cross the county. There are also many modern business parks and centres for research, no doubt benefiting from having the university city of Cambridge at its centre.

I do love a windmill, which will become apparent, and I have revisited several, including the magnificent Bourn Post Mill and Great Chishill Mill, right on the county border. Both show the work of preservation trusts to preserve them. For me the windmills are all about the harvest and its importance in a county like Cambridgeshire. It being September when I took these photographs, the harvest had been safely gathered in and many churches announced the forthcoming Harvest Festival. I was brought up on the tragic story of the five men hanged for their part in the Ely and Littleport bread riots of 1816, so being held up by a tractor trundling along on a narrow country road is a small price to pay for knowing that there will be food in the shops.

Because it was September I missed seeing cricket on the wonderful village greens at Barrington and Eltisley, but I hope I have captured enough of the county's villages to encourage you to go out and explore the delights for yourself if you don't already know them.

Michael Rouse,
Ely, September 2012

Soham War Memorial, 1921

On Sunday 23 January 1921, Major General Sir G. W. Hare, KCMG CB unveiled Soham's war memorial in Red Lion Square. The vicar of Soham, the Revd J. C. Rust, read the dedication. It bore the names of 127 servicemen who died in action in the First World War, including my two uncles, Clem, aged sixteen, and Bert, who was twenty-one. Such village memorials remind us of the young men who answered the nation's call to arms and the dreadful loss of life in that community. The Soham memorial is being restored by Jeremy Reader of JK Memorials, a local stonemason, funded by the Town Council and the generosity of the late Mr Eric Day of Soham.

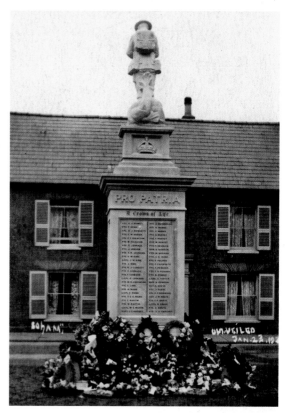

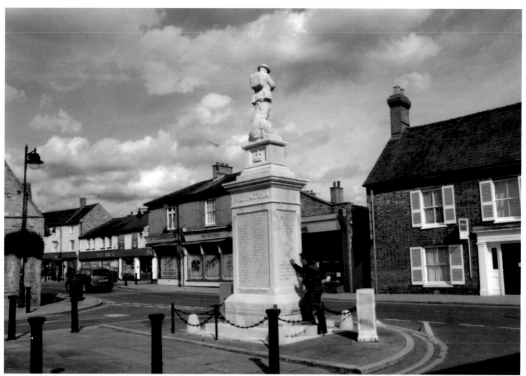

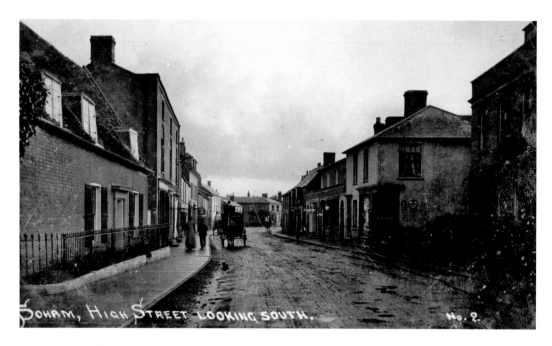

High Street, Soham, *c.* 1910

Any journey around the old county has to begin somewhere and Soham was one of the largest villages, certainly the longest, in Cambridgeshire. The name Soham means 'settlement by the sea', as the vast Soham Mere ran alongside it and to the edge of Ely. Soham is a Fen Edge settlement and was always reliant on the surrounding agriculture. Today's High Street is very different from a century ago, with a tanning parlour, hairdresser, betting shop, a tattoo parlour, takeaways and cafés.

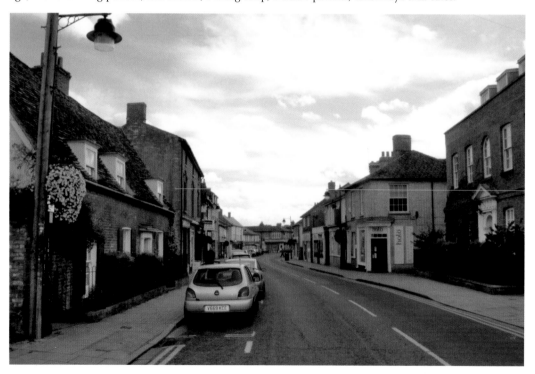

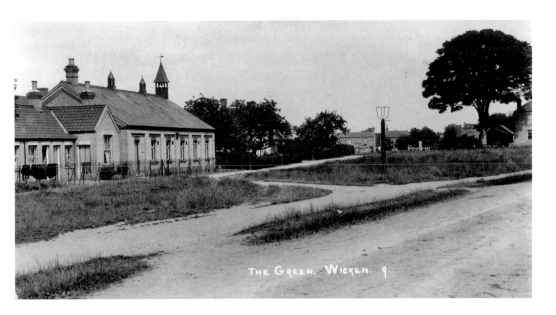

THE GREEN. WICKEN. 9.

Wicken Green, *c.* 1912

Across the Mere from Soham, Wicken always maintained a fierce independence, but now with no village school or shop it depends more on Soham. Wicken Fen on the edge of the village has an international reputation, but the village itself is full of character. On the left in this view are the Jubilee almshouses of 1897, replaced by three modern units in 1992. The Mission Hall was built to commemorate the Jubilee of 1887 and to provide a place of worship for those who could not easily get to the church on the edge of the village. It is now the village hall.

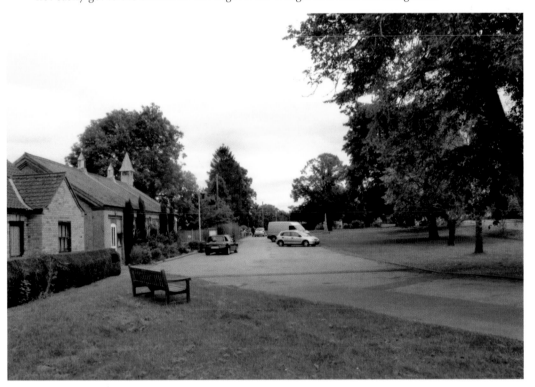

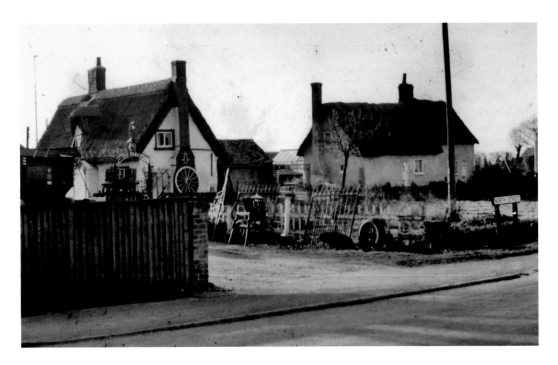

Wicken Forge, *c.* 1972

The village blacksmith and farrier was once a familiar figure in most rural villages, where machinery needed repairing and working horses shod. The old cottage probably dates from the mid-seventeenth century, while the forge building itself is probably about 200 years old. The Reddit family were blacksmiths at the old forge for many years in the twentieth century, until James Garton took over the business, but after his retirement the whole site is likely to become just residential.

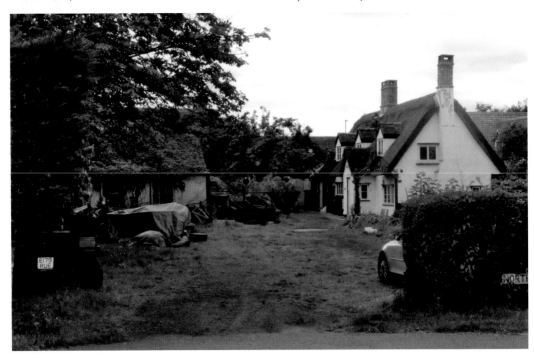

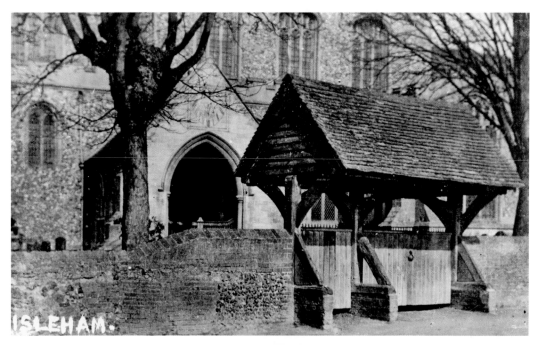

ISLEHAM.

Lych-Gate, St Andrew's Church, Isleham, *c.* 1912

On the other side of Soham, Isleham was another isolated village; the road to Prickwillow wasn't constructed until the Second World War. The village is rich in history, with a Norman Benedictine priory church, later used as a barn, and an ancient church with brasses to the Peyton family. The beautiful lych-gate is probably late fifteenth- or early sixteenth-century, while the tower that can be seen in the photograph below was rebuilt in 1863 after the earlier one collapsed.

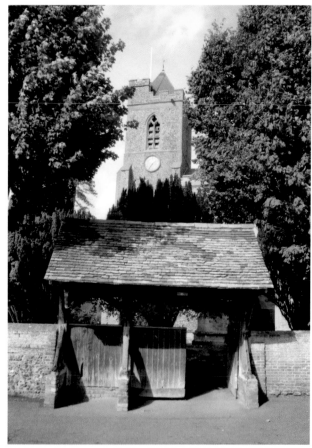

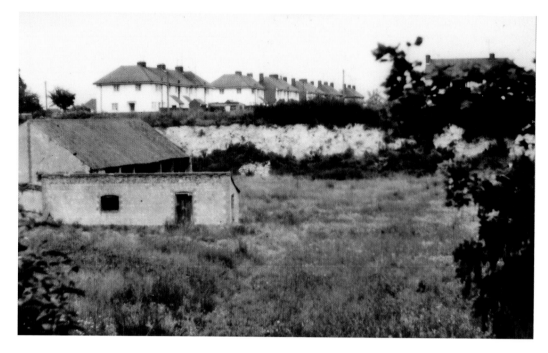

Isleham Chalk Pit, *c.* 1972

Isleham stands on the River Lark, famous for its river baptisms. The Lark provided a highway for goods, particularly local peat turves, and was known as the 'coal river' because of the amount of coal carried in barges along it. Isleham provides water for Soham and Ely from the chalk. There are several old quarries and there is an ancient limekiln in one, now Limestone Close. In the mid-nineteenth century it was reported that hundreds of people were living in these quarries in great poverty. This old quarry is now Robin's Close, having in recent years been developed with housing.

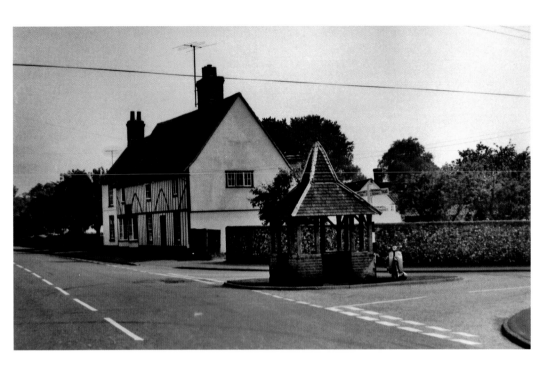

Chippenham, c. 1972

When Edward Russell, later Lord Orford, bought the Chippenham estate in 1696 he demolished the southern part of the village to create an enclosed park. He endowed the village school in 1714, but it is now a private house. The Tharp family who later owned the hall gave their name to the village pub on the left. The village pump and shelter can be seen on the right. Chippenham and Isleham churches are now part of the Three Rivers Group.

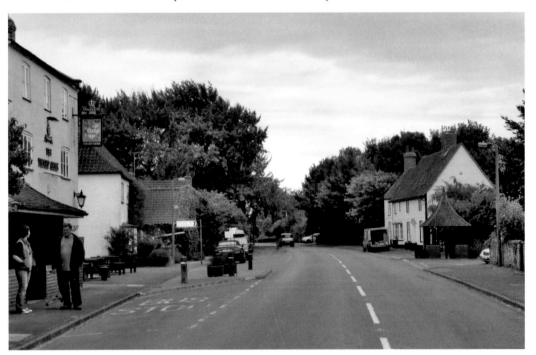

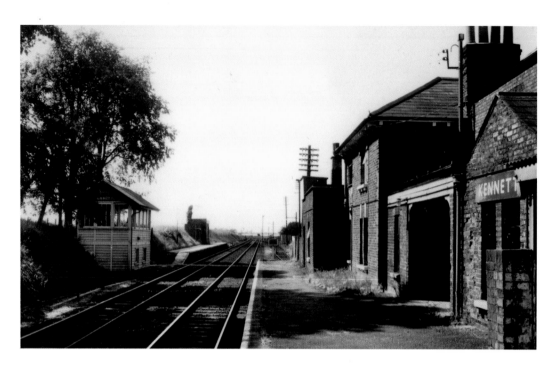

Kennett Station, 1960s

Kennett, right on the Suffolk border, managed to keep its little school when many were losing theirs and it has gone from strength to strength. Again one of the Three Rivers Group, it also managed to keep its railway link. Kennett station is on the Cambridge to Ipswich line and was opened in 1854 when the railway was extended from Newmarket to Bury St Edmunds. In 1967, it became an unstaffed halt and several of the old station buildings were demolished. In the last year, the signal box has gone and a new temporary footbridge has been erected.

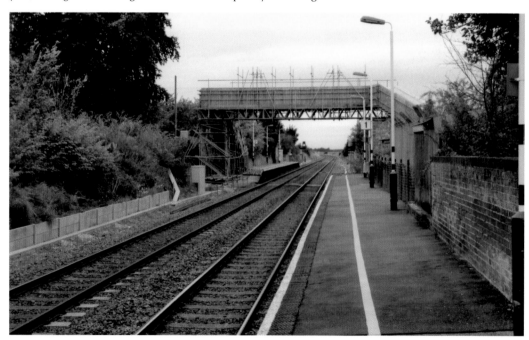

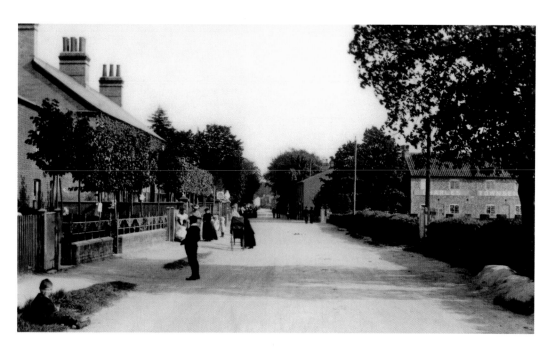

Market Street, Fordham, c. 1908

Market Street was the old main road through the village before the A142 bypass. Rochester Villas, on the left, date from 1900. Next door, at Shrublands, lived George Townsend. He began his nursery and seed business here in the mid-nineteenth century. The old flint building on the right, part of the nursery, dates from 1852. George's son, Charles Townsend, owned the business until the 1960s. Today, Fordham Nursery & Garden Centre occupies the site, and there is a small Woodland Trust wood behind Shrublands as part of the Townsends' legacy.

13

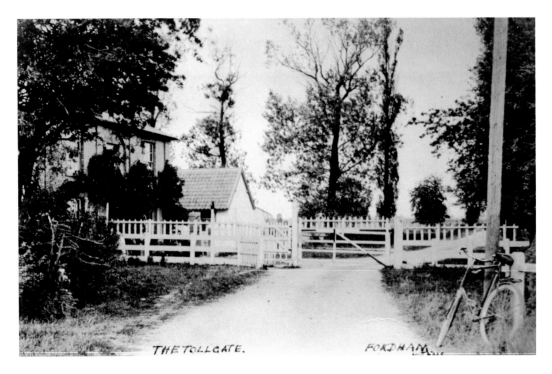

THE TOLLGATE. FORDHAM.

The Toll-gate, Fordham, c. 1904

The toll-gate stood at Ness Farm on the Fordham to Burwell road. The photograph was taken by William Tams, who was butler to the master of St John's College, Cambridge, and later official photographer to the university. There is a roadside stone erected to commemorate the removal of the toll on 15 December 1905. Over the years buildings have been replaced, the road has been moved and the stone itself relocated into the verge alongside the present road.

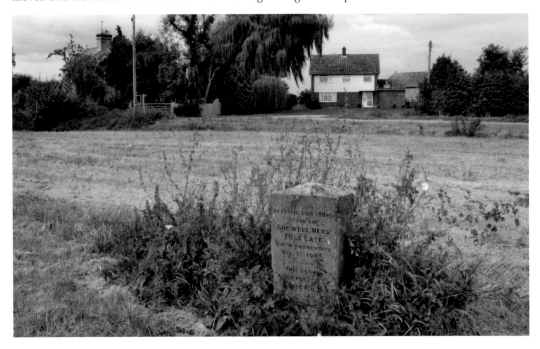

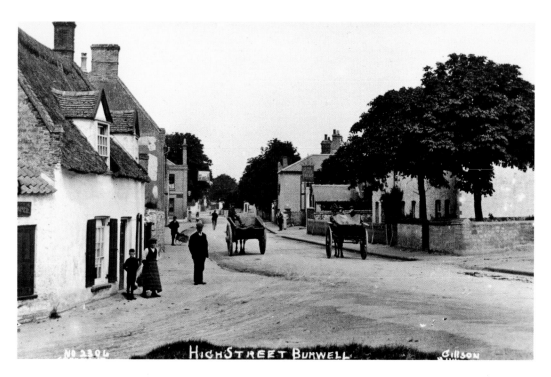

High Street, Burwell, *c.* 1906

Frederick Gillson, who had a photographer's business in the High Street, captured many of the street scenes and events in the village in the early years of the twentieth century. Around this time, Burwell, which is one of the larger villages following the edge of the Fens, had a population around 2,000. Today the population is around 6,500 and the village is popular with those who drive to work in Cambridge.

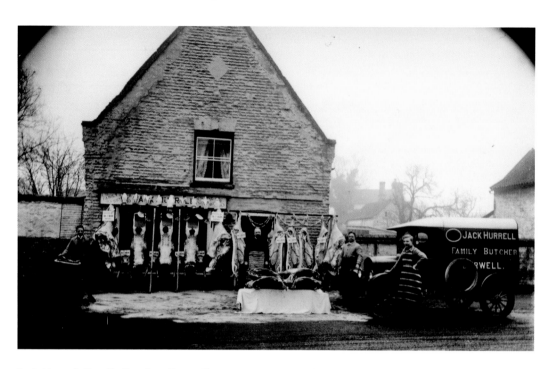

Jack Hurrell, Family Butcher, Burwell, *c.* 1925
A Christmas display of meat at Hurrell's butchers was caught by local photographer Dorothy Grainger. Henry Hurrell, standing in the doorway, founded the business in the early 1900s and his son, Jack, in front of the delivery van, carried on with the business. Today, the third generation of the Hurrell family continues to serve the village. Peter Curtis, the butcher, stands in the shop door.

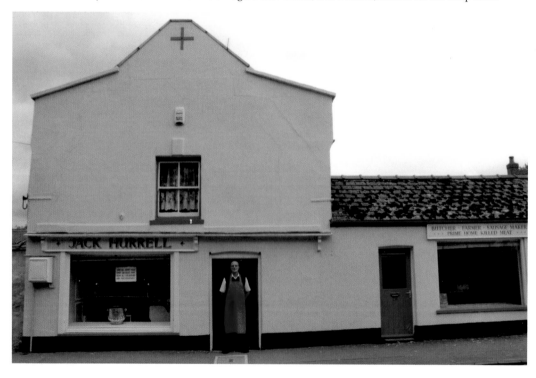

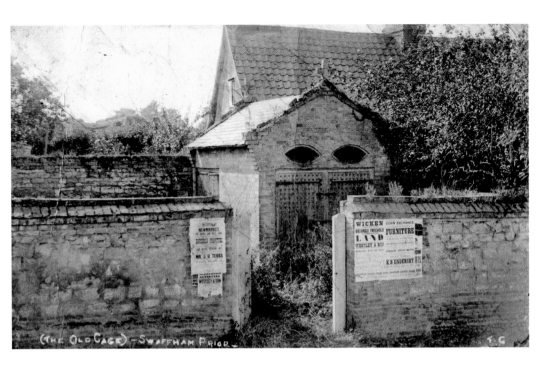

Swaffham Prior Pound, 1907

Remarkable for its two churches in the same churchyard, this picturesque little village also has its old village pound, dating from around 1830, with a cage for stray animals and a lock-up for straying humans. The inscription on the back of this photograph, taken by Frederick Gillson, is to the point: 'This is where they put all prisoners if they cannot get a trap to take them to the Police Station 4 miles away and have to wait.' Posters on the wall announce various auctions and sales of land and furniture. The village fire engine, given by the Allix family of Swaffham Prior Hall in 1791, was housed here.

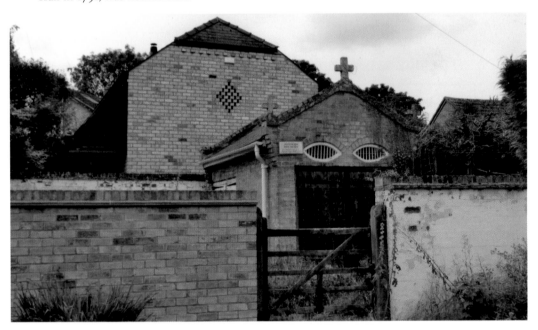

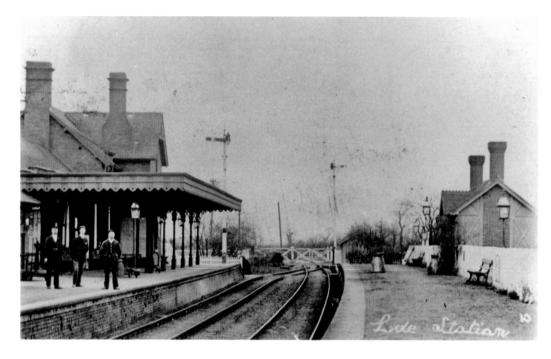

Lode Railway Station, c. 1905

The delightful hamlet of Lode is often discovered by visitors to the National Trust's Anglesey Abbey, which is alongside it. As the name suggests, Lode was the port for Bottisham at the head of Bottisham Lode, one of several lodes connecting the Fen Edge villages to the River Cam. In 1884, the Great Eastern Railway opened its line from Cambridge to Fordham, before continuing it to Mildenhall the next year. The port died and the line closed to passengers in 1962 and a few years after to goods as well.

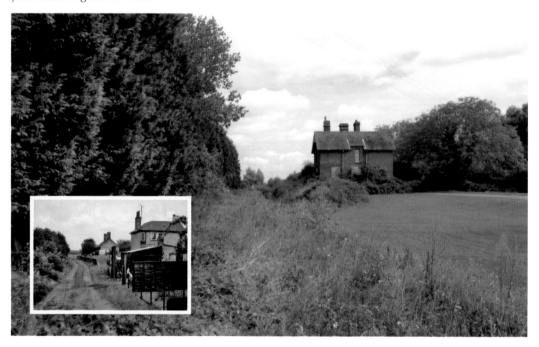

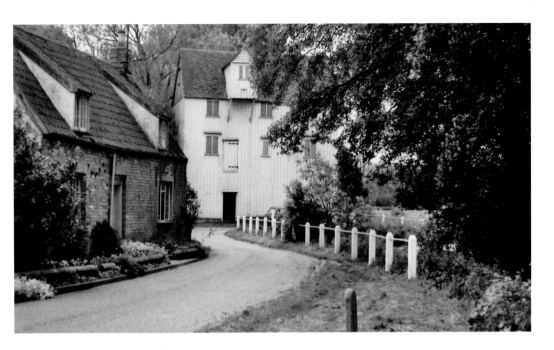

Lode Mill, *c.* 1972

A watermill has stood on this site on the Quy Water since the time of the Domesday Book in 1086. This mill is probably late eighteenth-century and in 1900 was converted from corn grinding to cement grinding by the Bottisham Lode & Brick Company, Bottisham Lode being the water below the mill. Lord Fairhaven, who had bought Anglesey Abbey in 1926, acquired the mill in 1934 and restored it as a corn mill. On his death in 1966, Anglesey Abbey and the mill were left to the National Trust. In 1978 the Cambridgeshire Wind & Watermill Society restored the mill to working order.

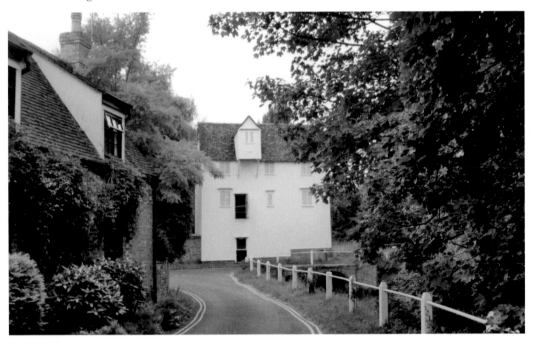

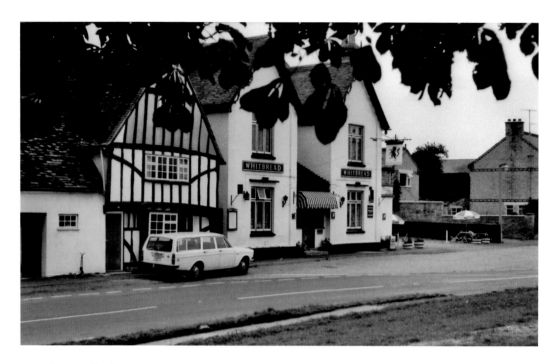

Swaffham Bulbeck, c. 1972
The Black Horse is a traditional village inn that has been on its present site since 1889. Next to it is the village store, and with that an Indian takeaway. The busy Burwell to Cambridge road separates it from the large village playing field and many who simply travel along the main road see little of the charm of the village, but by taking the Bottisham Road many very attractive, half-timbered buildings and the church and village school can be found.

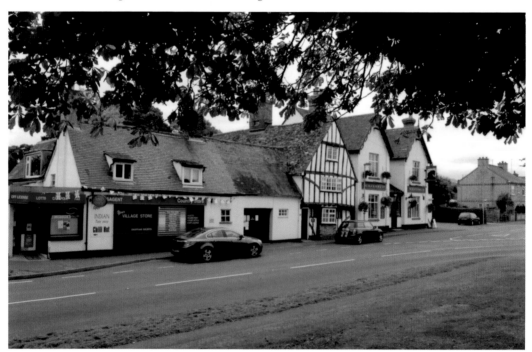

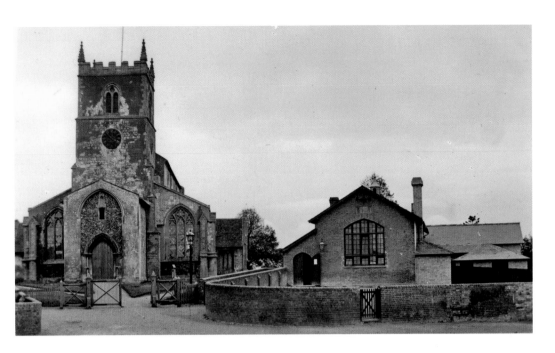

Bottisham, *c.* 1910
The fine Holy Trinity church is set back from the main street that runs through this charming and historic village. The old church school next to it was opened in 1838 and closed when the village college, only the second of Henry Morris's visionary community schools, opened in 1937. After being used as a youth club and for other community functions, it is now being converted into a restaurant.

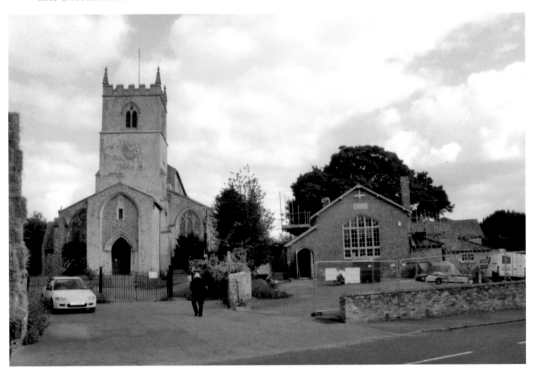

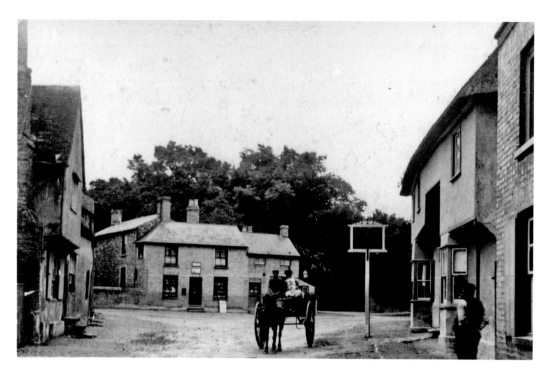

Fulbourn, *c.* 1903
A photograph by Cambridge photographer Ralph Starr, who later went into partnership with Will Rignall of Ely to form one of the best-known photographic names in the first half of the twentieth century, Starr & Rignall, with studios in both towns. The Six Bells is still in business at this very busy point in the village alongside other shops, Amanda's charming café and a real greengrocer.

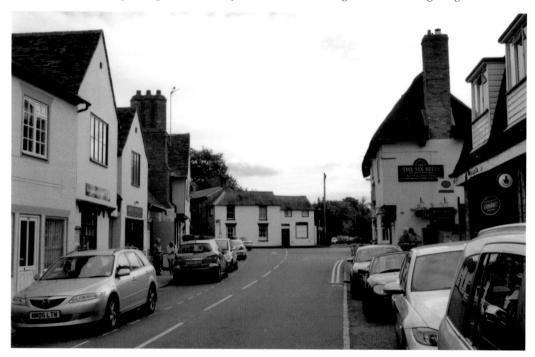

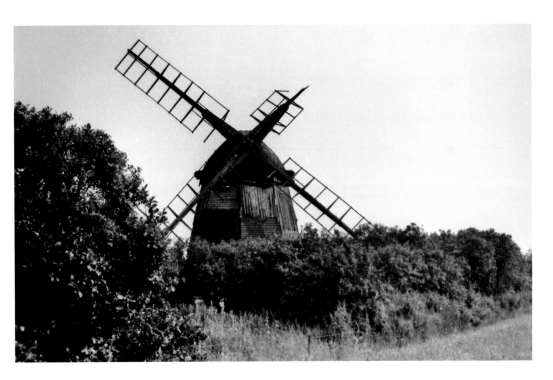

Fulbourn Windmill, c. 1972

The mill was in a very poor state of repair when I first photographed it. It was built in 1808 by local landowner and farmer John Chaplin, whose family worked it for over 100 years. C. J. Mapey then owned it, but in the mid-1930s its fortunes declined and, after lightning strikes, the mill was left to decay. In 1975, the Fulbourn Windmill Society was formed and the mill was restored.

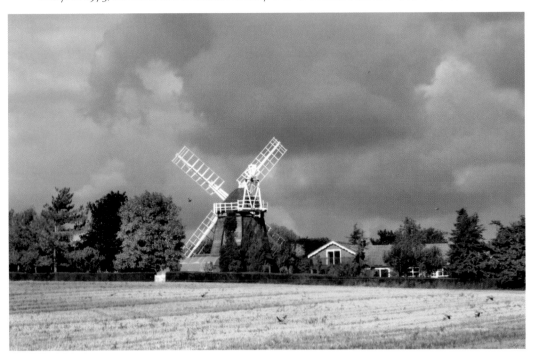

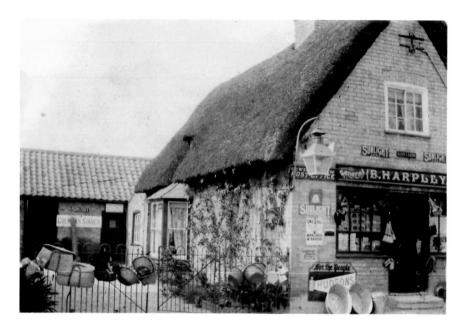

The Post Office, Great Wilbraham

What an incredible development the postal service was! How it opened up the world for small villages like Great Wilbraham. Letters and postcards kept you in touch with family and friends, appointments could be made and visits arranged, all very quickly. Such was the popularity of the postcard that E. W. Morley, photographer and post office manager at Linton, supplied and sold some 60,000 cards a year before the First World War. Sadly, the small post offices have dwindled and this one is now a very attractive private home.

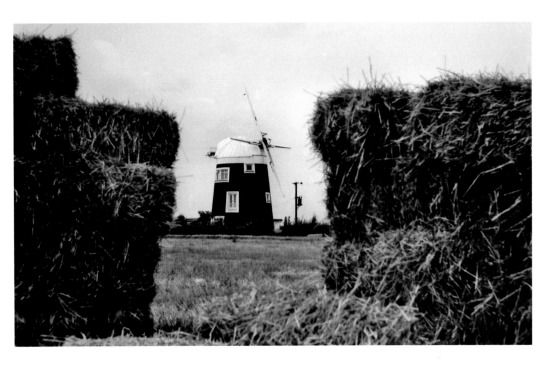

Little Wilbraham Mill, *c. 1972*

Little Wilbraham Mill has had different fortunes from Fulbourn Mill. It was a tower mill, built around 1820, and since I photographed it the sails have been removed and the rest of the mill converted into a private residence. Before plunging deeper into Cambridgeshire, I want to return to the borders of Suffolk. For historic reasons, Newmarket and Exning form an enclave into Cambridgeshire and the villages to the east of the M11 have a definite feel of Suffolk about them.

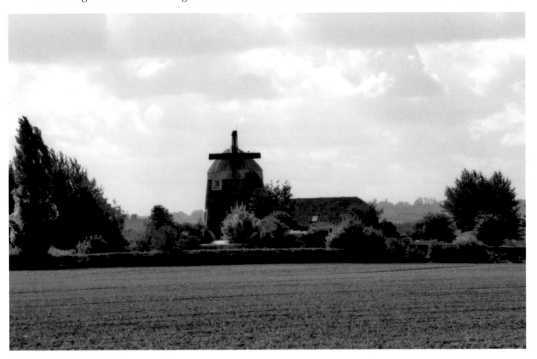

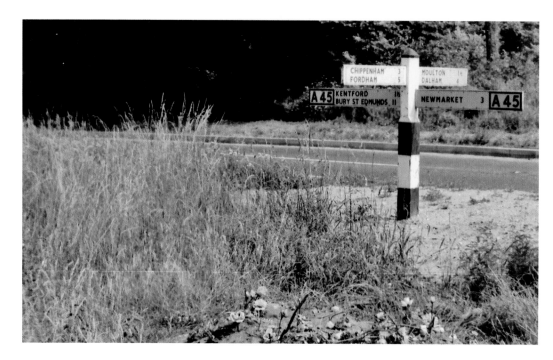

Gypsy Boy Grave, c. 1972

This grave is at the Chippenham to Moulton crossroads with the Kentford to Newmarket road, right on the border with Suffolk. My late father used to point it out to me, saddened by the story of a poor gypsy boy who fell asleep while watching his sheep and thought he had lost one so hanged himself in remorse. In recent years, a lady who tended the grave put up a cross with the words, 'To Joseph the unknown gypsy boy.' The grave is the subject of several stories of ghostly happenings and legends about the colours of Derby winners on ribbons tied there.

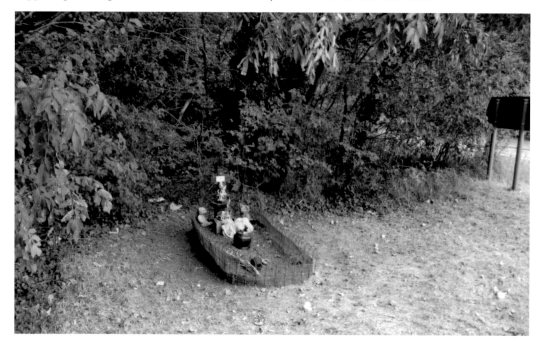

Cheveley, c. 1972

Cheveley is in the heart of the studlands that surround Newmarket. The Cheveley Park Stud is known throughout the racing world and gave its name to the Cheveley Park Stakes. The Star & Garter public house has now been replaced by a very attractive thatched residence, while the name lives on in the adjoining road. The Red Lion in the village has recently been refurbished, so Cheveley still has one hostelry.

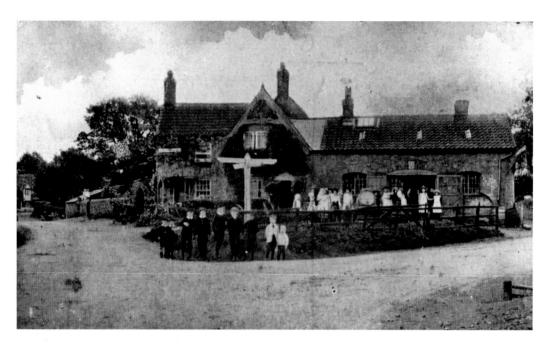

Ashley, c. 1905

A village event of some sort is taking place, seemingly connected with the workshop on the right. The house is dated 1869. The Crown public house is to the left of where the photographer is standing. Ashley is close to the Suffolk border and at the time of this photograph there was a blacksmith, a wheelwright, hurdle makers, a thatcher and a miller, all serving a population of under 600.

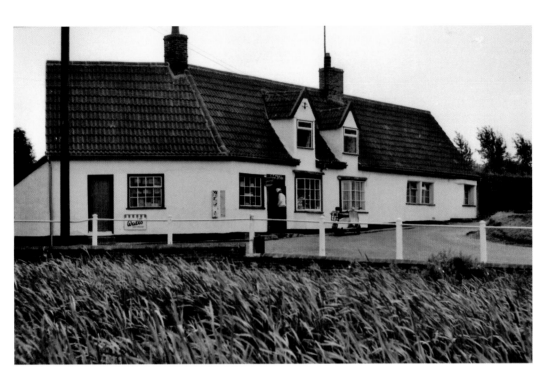

Ashley, 1972
West's Stores next to the village pond is now residential, but the village pond that was full of reeds is now much better cared for, the area around it an attractive feature in the village. With the pastel-coloured walls, roofs of thatch, and the use of flint in the cottages and walls, Ashley is typical of the villages in and around the Suffolk border.

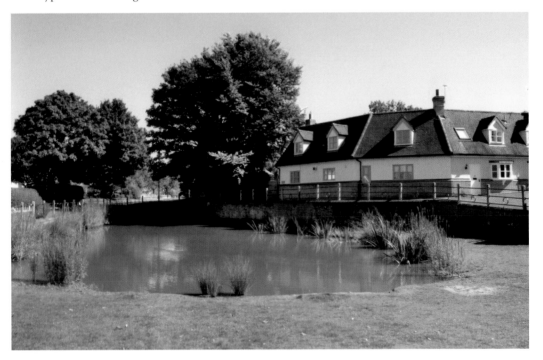

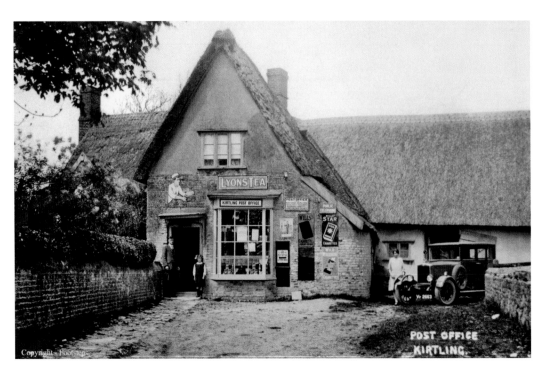

Kirtling Post Office, *c.* 1925
Kirtling is a quiet rural village spread alongside winding roads. The Red Lion public house is still open, but the old post office also on The Street has been converted into an impressive residence. The postbox at the roadside is some compensation, I suppose, for losing a village shop like this.

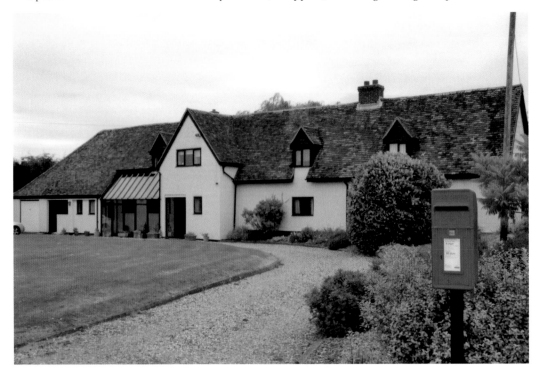

Dullingham, *c.* 1972
In forty years, the only marked change is the growth in the trees and the speed and frequency of vehicles coming to and from Newmarket on the road through the village. The King's Head, in the centre of the photograph, has been a public house since the 1720s. Originally owned by a village charity, with income from the rent helping the poor of the parish, in 1931 the King's Head was sold into private ownership.

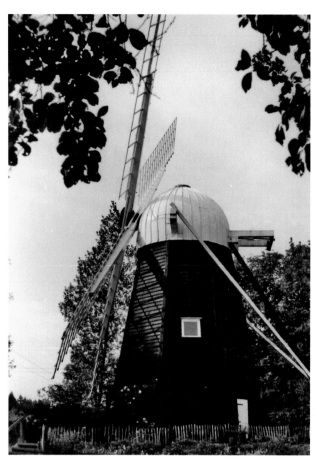

West Wratting Windmill,
c. 1972
Robert Stevens, in his book
*Cambridgeshire Windmills and
Watermills,* writes, 'Tucked away
behind trees, on low hills and
away from main roads, stands
this small but imposing mill of
relative antiquity. It is the oldest
dated smock mill in Britain,
having W 1726 boldly carved
on its brakewheel.' Bought by
Miss Vera Pompei in 1957, who
carried out extensive repairs, and
still privately owned, it appears
to be in fine condition.

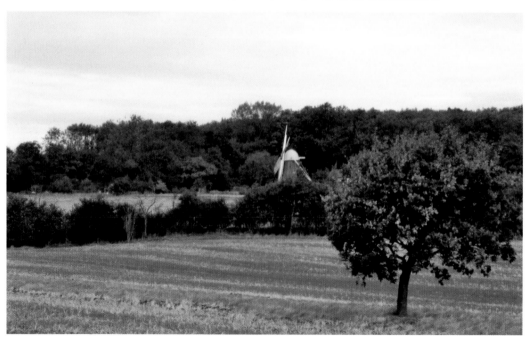

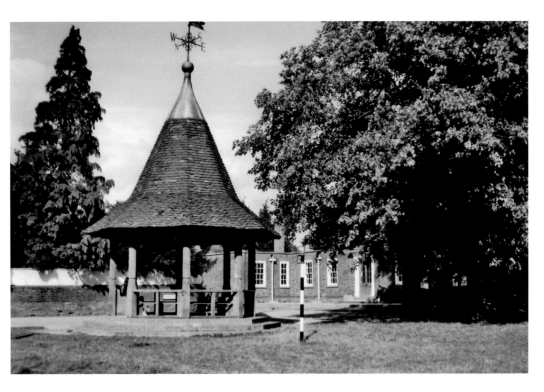

Shelter at Balsham, c. 1972

Balsham is a well-maintained village with a large church and a lively community. The Prince Memorial shelter was erected in 1932 and stands opposite the village green in front of the old school.

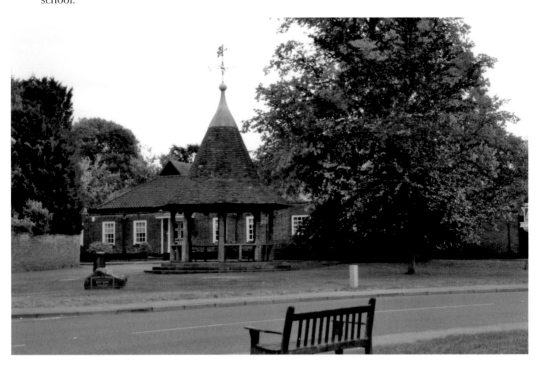

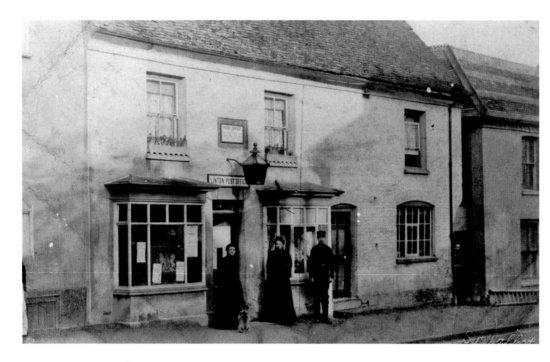

Linton Post Office, c. 1902

Stanley F. Talbot was a Linton photographer from his premises in Market Lane and this is one of his photographs, showing Miss Mary Nottage, the sub-postmistress, and her Linton post office on the High Street. At this time Linton had a population of around 1,530, which included sixty-five officers and inmates of the workhouse. The 1904 directory says, 'The town consists principally of one long street, about a mile long, and is lighted with lamps by the Parish Council.' Today you can add, 'and a one-way system'.

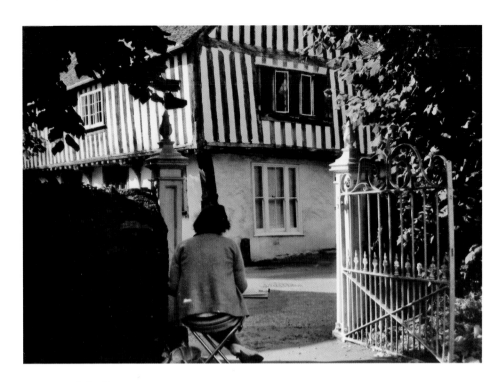

Linton Guildhall, *c.* **1972**

The Guildhall dates from 1523. It is opposite the parish church of St Mary's and next to the River Granta, which flows through the village. Linton probably has a population now of over 4,500, with many residents commuting to work. It has a wealth of old and beautiful buildings and on taking today's photograph I pulled back to catch a glimpse of a thatcher re-roofing the nearby barn.

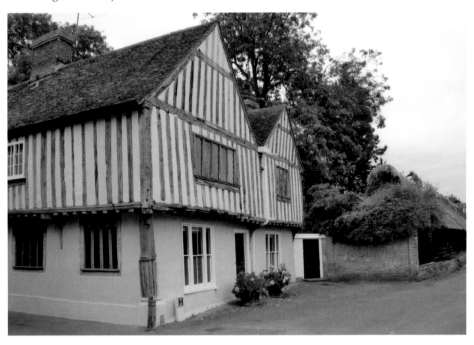

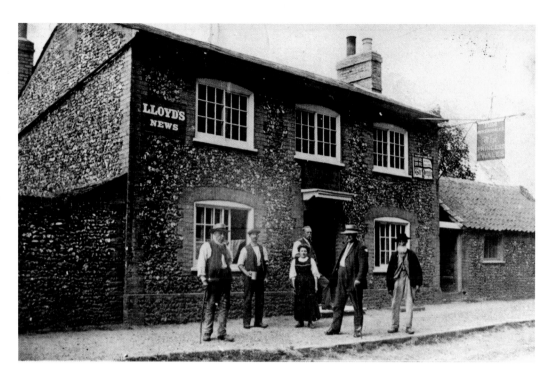

The Princess of Wales, Little Abington, c. 1906

Little Abington, like Linton, is on the River Granta as it flows towards Cambridge. It was a small settlement at the time of this photograph, with a population of just over 200, but only fifty or so less than its sister, Great Abington. John Burnder kept the Princess of Wales and the landlady is in the centre of the photograph. For a while known as the Prince of Wales, the pub closed, probably in the 1970s, and is now a private house.

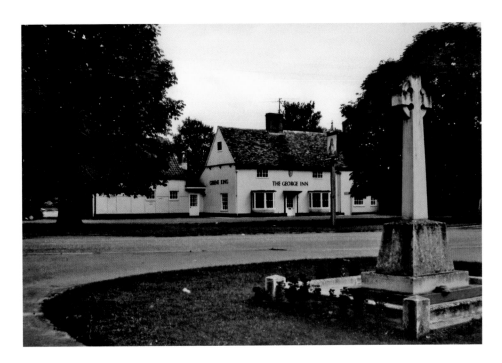

George Inn, Babraham, c. 1972

Another small village on the River Granta, Babraham is well known for the research campus with the internationally recognised life sciences centre, Babraham Institute, based in and around Babraham Hall. The George Inn is the last surviving public house in the village and appears much livelier today than when I photographed it in 1972, obviously benefiting from the Research Campus. There has been an inn on the site since the fifteenth century and the George dates from around 1600.

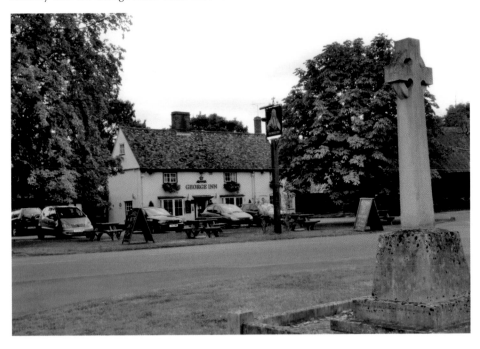

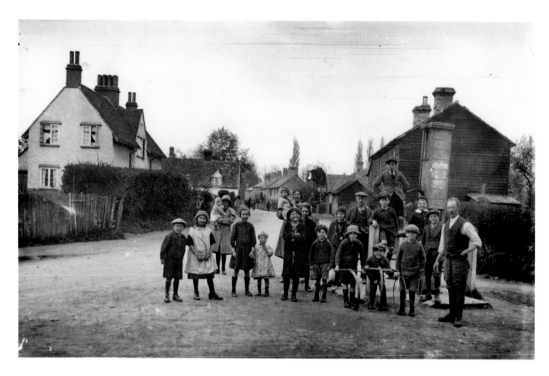

Stapleford Pump, *c.* 1920

A group gathers for local photographer Ted Mott around Stapleford's village pump. Stapleford is another village on the River Granta and the pump stood at the junction of Bar Lane and Bury Road. Three of the children have hoops to bowl along; one is iron and two are old bicycle tyres. Once the village got mains water in 1936 the old pump was no longer the meeting point, and it appears to have been taken down in the late 1940s.

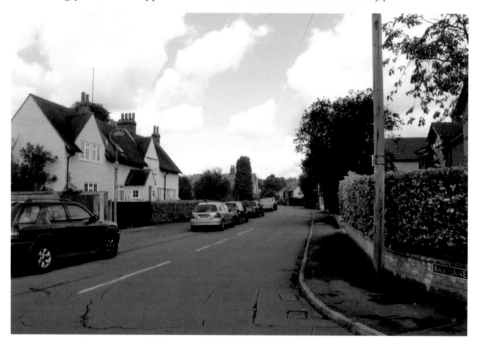

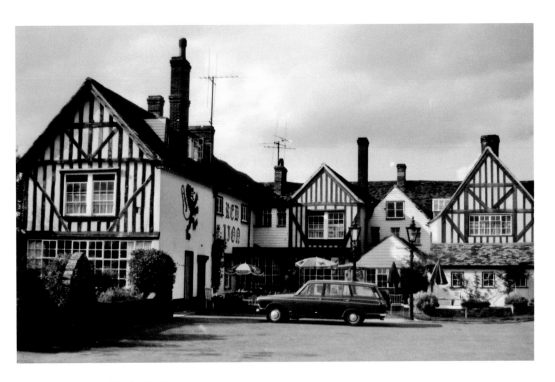

Red Lion, Whittlesford, *c.* 1972

Forty years on and the ancient Red Lion at Whittlesford Bridge, and the area around it, has been transformed. The 700-year-old inn, once a popular local for the servicemen and women at RAF Duxford, has been totally modernised. A Holiday Inn Express now stands beside it and a large car park for the Whittlesford Parkway railway halt on the London to Cambridge line has been developed. The busy A505 passes by, and it is just off a junction with the M11.

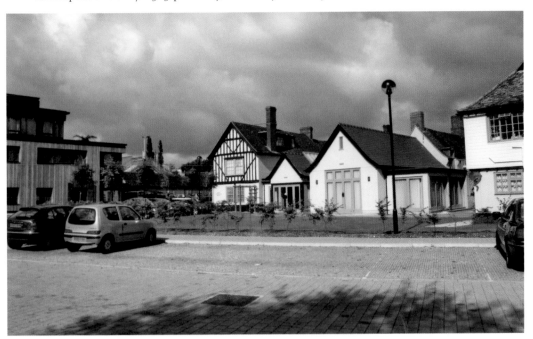

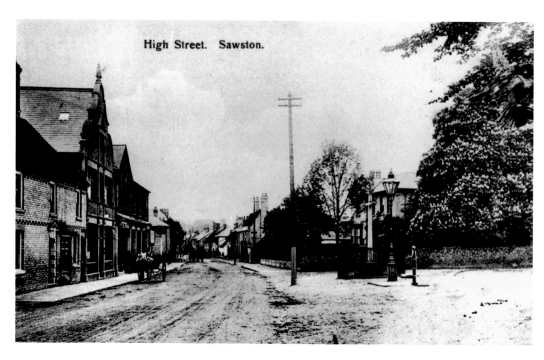

High Street. Sawston.

High Street, Sawston, c. 1909

Sawston is a large village on the River Cam. In 1901, the population was 1,699; today it is over 7,000 and likely to grow more under South Cambridgeshire District Council plans. The first of Henry Morris' village colleges was opened here in 1930. Local chemist and sub-postmaster Abraham Coulthard, who had a business in the High Street, published this postcard.

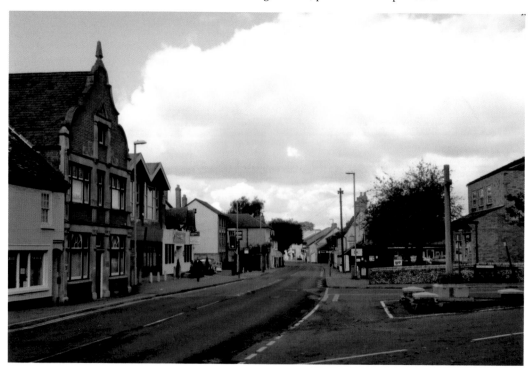

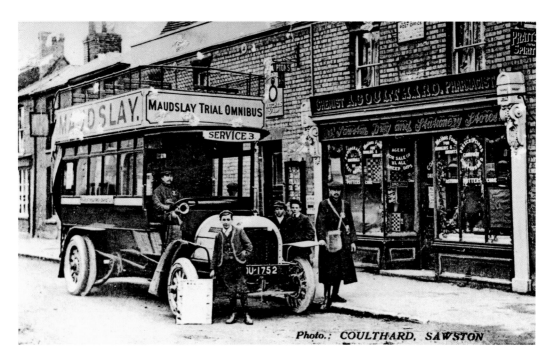

Photo.: COULTHARD, SAWSTON

Maudslay Trial Bus, Sawston, *c.* 1910
The bus is outside Coulthard's Drug & Stationery Stores. The bus service between Sawston and Cambridge along the old London Road was begun around 1910 by the Ortona Bus Company. There are still buses today, threading their way among the cars along the much changed High Street.

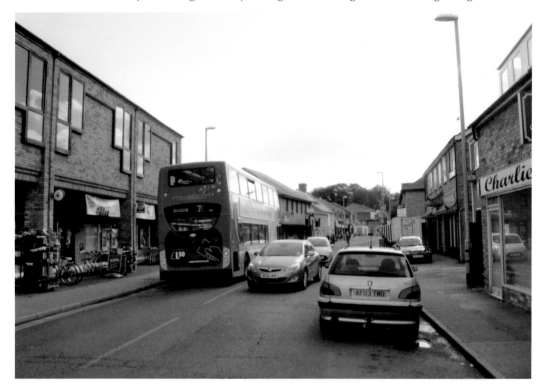

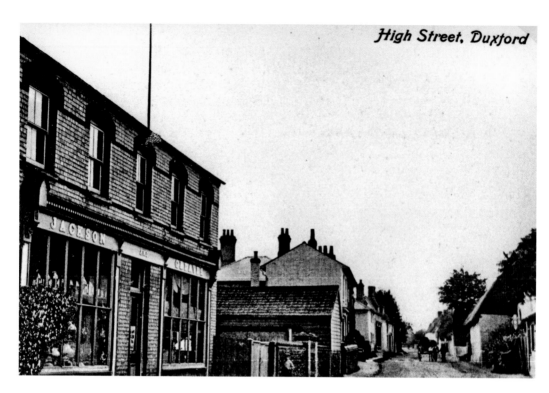

High Street, Duxford

Jackson & Greaves's shop has long gone, although the building is easily recognisable. Almost opposite it, the Wheatsheaf is open for business. The street is now called St Peter's Street and the picturesque village church of St Peter's is behind us both as we take the photographs. The village of Duxford is quite separate from the Imperial War Museum at Duxford.

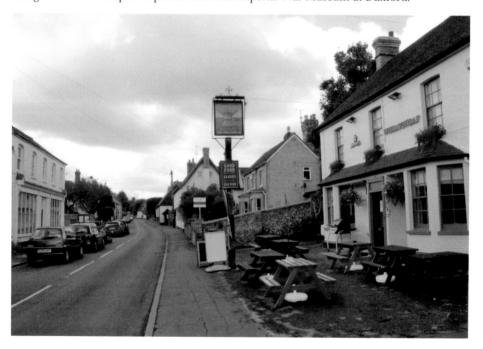

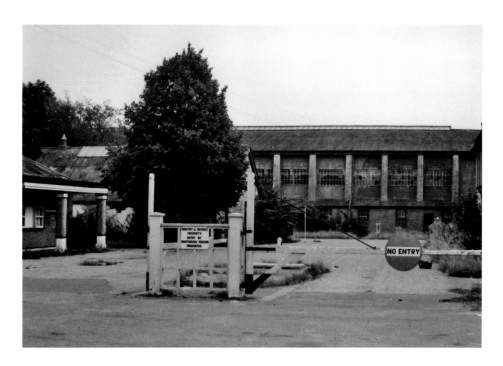

Gatehouse, RAF Duxford, c. 1972

I took this photograph when the future of the old RAF station was undecided. Opened in 1917 for the Royal Flying Corps, RAF Duxford played a prominent part in the Battle of Britain as a fighter station. In 1943, the USAAF took over the base until the end of the war. My father completed his wartime service in 1948 at Duxford as a sergeant in the RAF police, so he knew the gatehouse very well. The station closed in 1961, but in 1977 it was acquired by the Imperial War Museum and is now the European centre of aviation history.

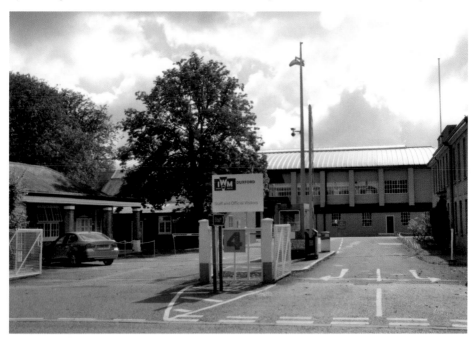

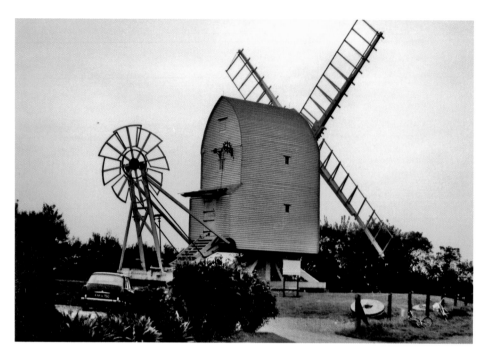

Great Chishill Windmill, *c.* 1972

The furthest south in the old county, Great Chishill sits on the edge of Essex. The mill is a fine post mill dating from 1726, but according to Robert Stevens was substantially rebuilt in 1819. The Pegram family were the last millers, giving up in about 1951 when the mill was in poor condition. Cambridgeshire County Council bought the mill in 1964 and carried out repairs. This year the mill has been acquired by the Great Chishill Windmill Trust, who have ambitious plans to fully restore the mill, one of only five post mills in the country, and make it the only one to produce flour again.

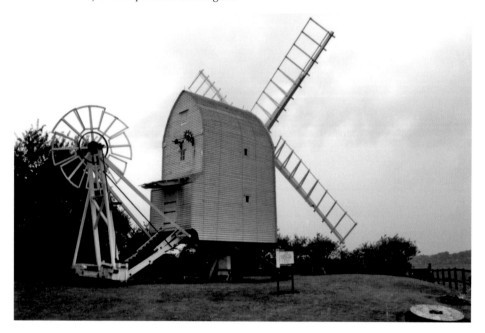

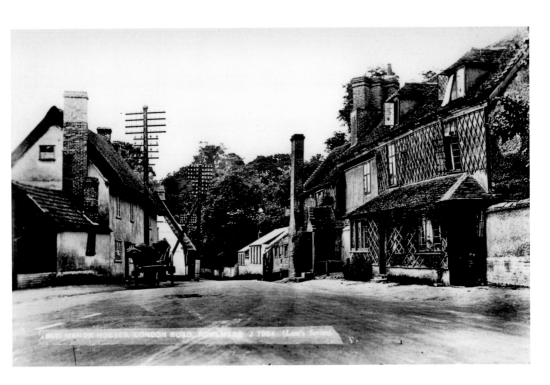

Fowlmere, 1910

The old manor houses on the London Road. For my photograph I am able to go further back and include the village war memorial. This is an attractive, small village. Like Duxford it had an airfield during the Second World War, which was operationally linked to RAF Duxford and was also used by the USAAF.

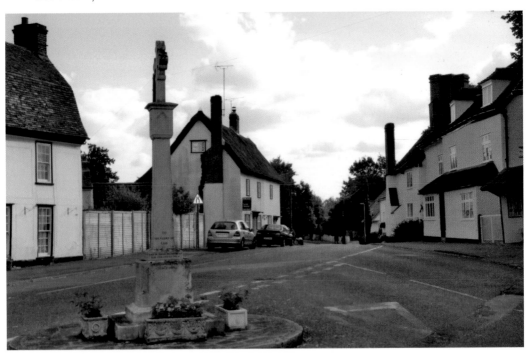

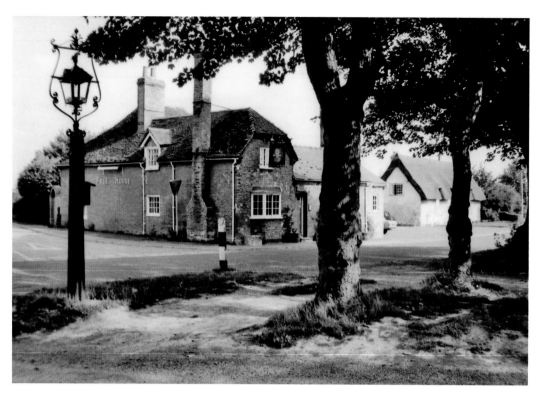

Newton, *c.* 1972

Driving into Newton from Fowlmere, it is reassuring to find that forty years on the ancient Queen's Head is still thriving and that customers can sit under the shade of the trees to enjoy some refreshment. A village sign has been erected and the old lamppost still stands.

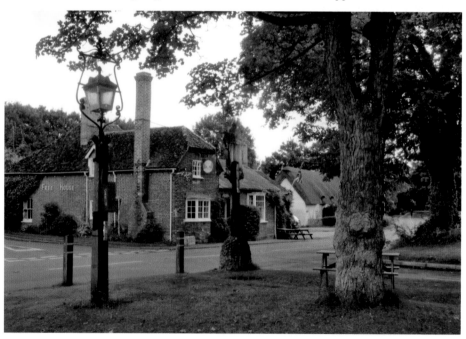

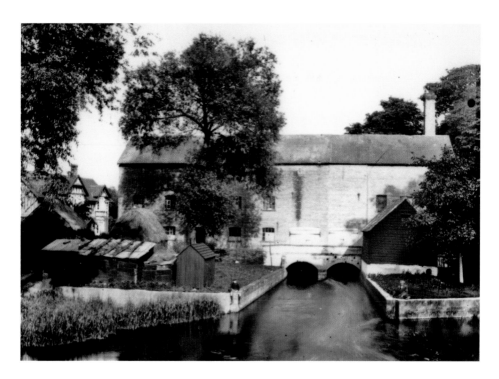

Hauxton Mill, *c.* 1920

Just off the main Cambridge to Royston road and on the River Granta or Cam, this ancient mill, much rebuilt in the nineteenth century, was working until about 1972. Its fate then became inextricably linked with the vast Fisons agrochemical factory next to it (see following photographs). After being used for storage, it was left to deteriorate and now it awaits the redevelopment of the nearby site and should become an attractive feature. My photograph was taken from the other side of the mill.

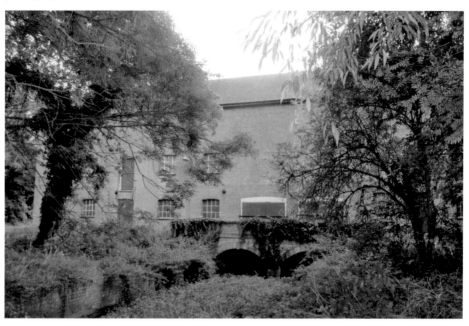

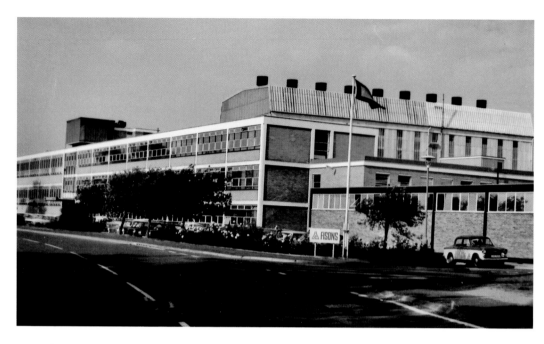

Fisons, c. 1972

It seems incredible that the vast Fisons agrochemical plant and offices alongside the A10 have now gone. Pest Control developed the site here after the Second World War. In 1954, Fisons acquired the business and developed the site for manufacturing and support staff, and by the time of this photograph was a major employer in the area. Bayer Crop Sciences acquired the business but closed the factory in April 2006. There is now planning permission for a mixed development on the site once all the contamination has been dealt with.

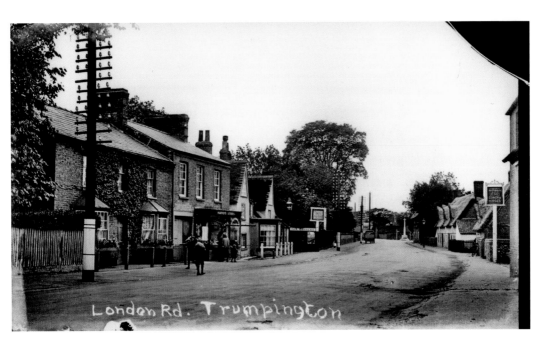

London Road, Trumpington, 1920s

Most of the photographs of Trumpington and Grantchester that now follow were taken by Edward (Ted) Mott (1876–1947), a photographer and small shopkeeper in Great Shelford, who lived in Shelford Road, Trumpington. The Coach & Horses on the right is now the Wok & Grill, while the Green Man over the road is still in business. The main difference is the vast amount of traffic on the road and that the ancient village is now being swallowed by development around Cambridge.

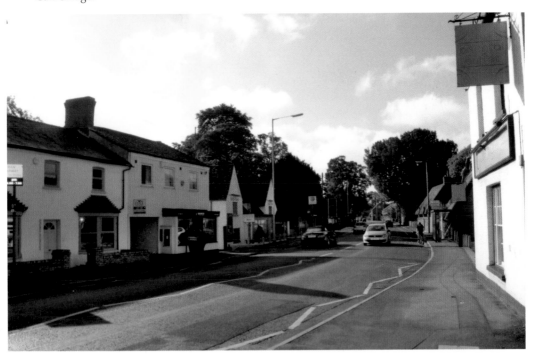

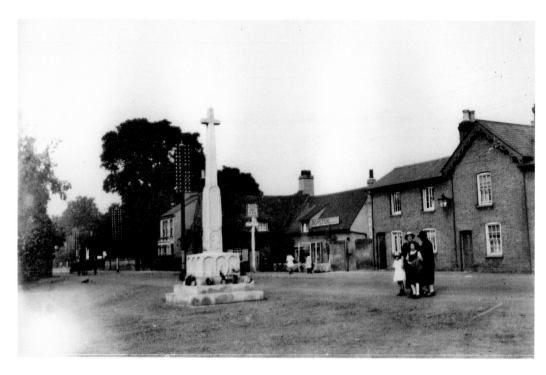

Trumpington War Memorial and Red Lion, 1920s
The old Red Lion in Trumpington. Walter Frost was the landlord in the 1920s and 1930s. The old Red Lion was in business for a century or so until demolition in 1936, when it was replaced by a much larger Red Lion that was also demolished, in 1975, and replaced by housing. The war memorial was the work of Eric Gill, the celebrated sculptor and master of letter carving, and was dedicated on 11 December 1921.

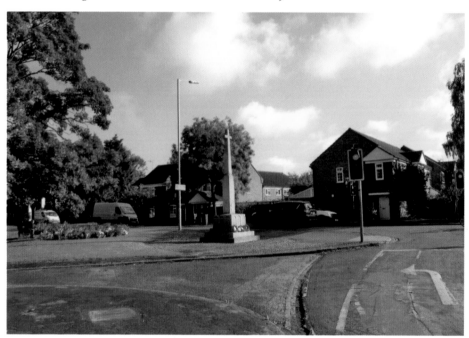

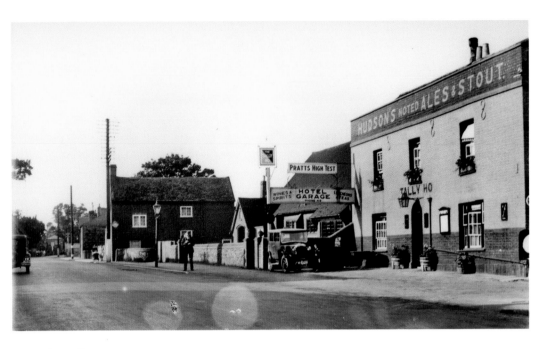

The Tally Ho, 1920s

At one time one of the nine public houses in Trumpington, which was the first major village on the London Road to the south of Cambridge, the Tally Ho is next to the village hall. For the last few years it has advertised itself with a sign for serving 'Authentic Thai Food', something that neither Ted Mott nor any of the locals in the 1920s would ever have dreamt of.

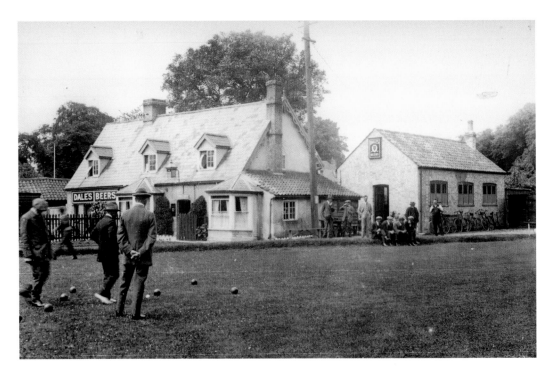

Unicorn Inn, Trumpington, 1920s

A wonderful Ted Mott photograph showing the bowling green alongside the Unicorn on Church Street. After 170 years trading as the Unicorn, in May of this year it became the Lord Byron. Car parking has replaced the bowling green, but the ancient inn is still immediately recognisable.

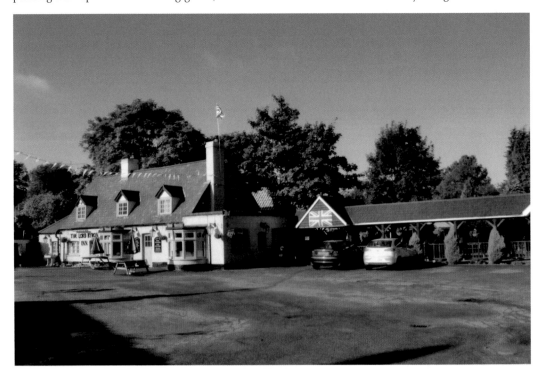

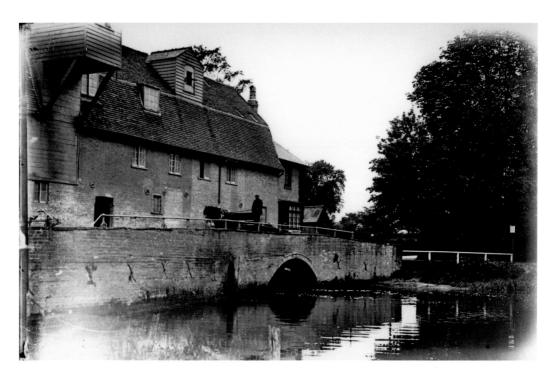

Grantchester Mill, *c.* 1925

The Lord Byron connection picked up in the previous photograph is mostly associated with the water mill at Grantchester, a short distance away. Lord Byron swam in the millpond here and it is known as Byron's Pool, reputedly haunted by the poet's ghost. The Nutter family were millers here for a century, but the mill was destroyed by a disastrous fire in 1928. The River Granta, also known as the Cam, flows through here and countless generations of undergraduates have boated from Cambridge up to here.

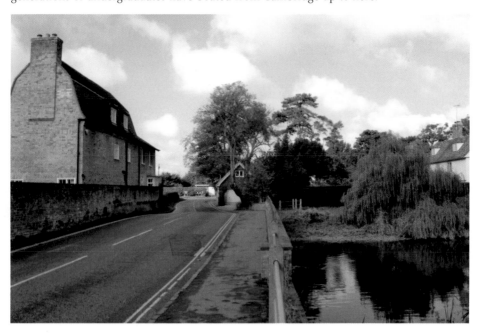

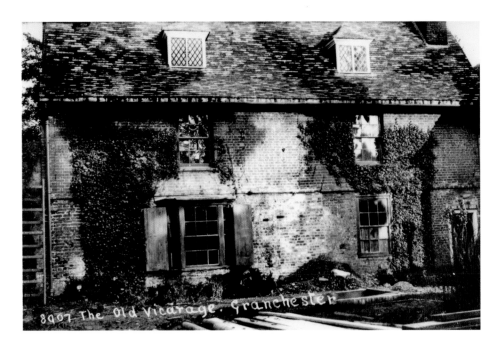

The Old Vicarage, Grantchester, 1920s

The major literary association with Grantchester is that of Rupert Brooke, who immortalised the village in his poem 'The Old Vicarage, Grantchester', written in Berlin in 1912. Brooke had graduated from King's College in 1909 and had rooms at the Old Vicarage. Now the home of Jeffrey and Mary Archer, there is a splendid statue there of the soldier-poet, who sadly died in 1915 of blood poisoning while on board a troop ship bound for Gallipoli and was buried on Skyros.

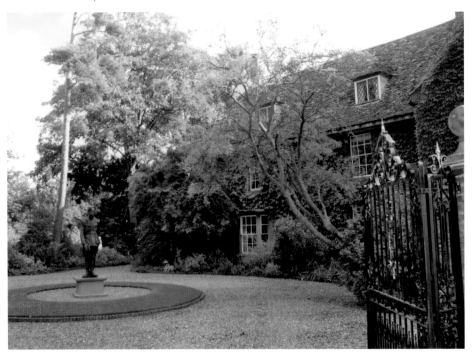

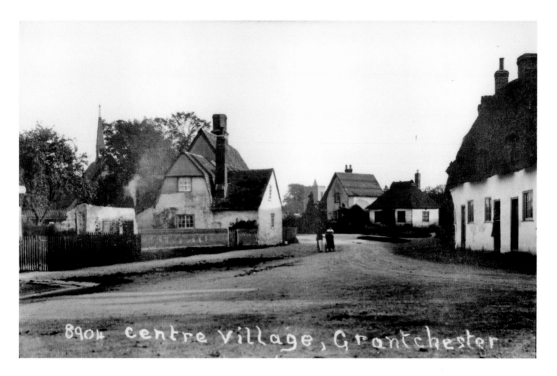

Centre Village, Grantchester, 1920s
'And Cambridgeshire, of all England/The shire for Men who Understand/And of that district I prefer/The lovely hamlet of Grantchester', so wrote Brooke in 'The Old Vicarage, Grantchester', some ten years or so before Ted Mott took this photograph. A century on and, apart from the cars, the street scene seems hardly to have changed.

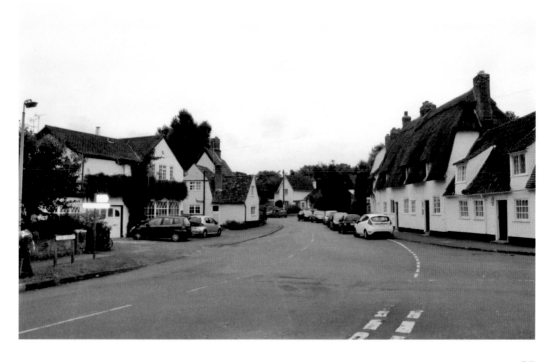

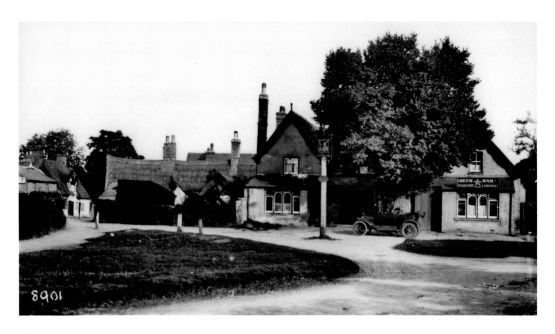

The Green Man, Grantchester, 1920s

There is a timelessness about Grantchester, as these photographs show. It has a feeling of being a very special village: 'Grantchester! Ah, Grantchester!/There's peace and holy quiet there.' Of course, public houses like the Green Man cater for modern needs, but they retain the character that Brooke would recognise.

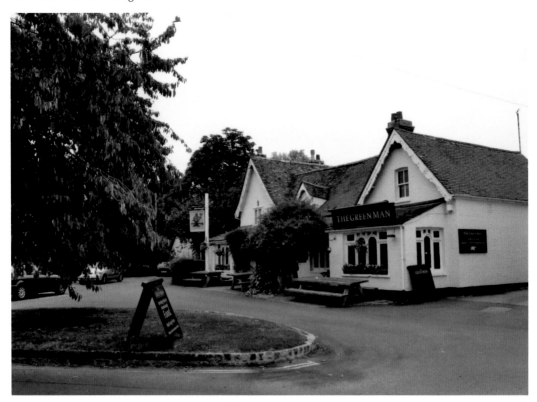

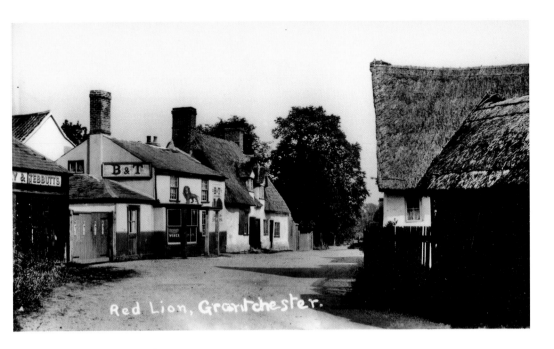

Red Lion, Grantchester.

The Red Lion, Grantchester, 1920s

Just around the corner from the Green Man and wearing its thick bonnet of thatch, the Red Lion, too, has moved with the times, but is instantly recognisable. Just visit the Orchard, next to the Old Vicarage, and enjoy refreshment in the tea room or sit on the deckchairs outside and recall those immortal lines: 'Stands the Church clock at ten to three?/And is there honey still for tea?' Of course there is, for this is Grantchester.

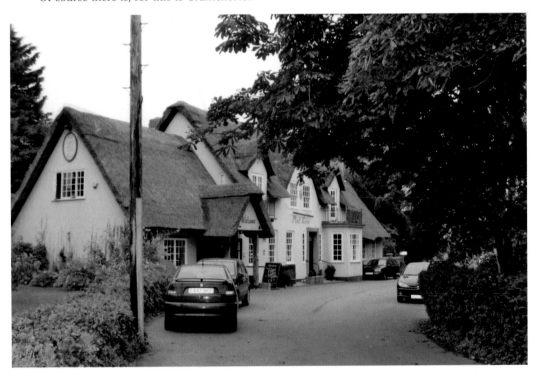

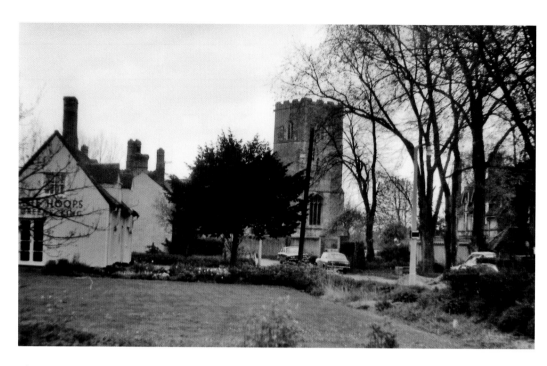

The Hoops, Barton, *c.* 1972
Another corner of rural Cambridgeshire full of character, Barton is only a few miles from Grantchester, though now separated by the M11. Why did Rupert Brooke write, 'And Barton men make cockney rhymes'? The Hoops, with its gardens, has a reputation for its well-served Greene King ales.

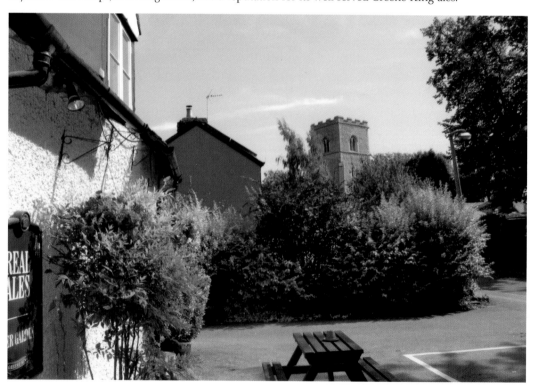

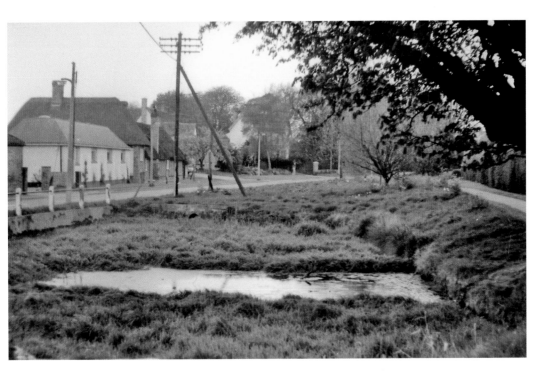

Barton Pond, c. 1972
The pond seems a lot healthier and there is a new village sign. Behind me are several shops and all the signs of a lively community and pride in the village.

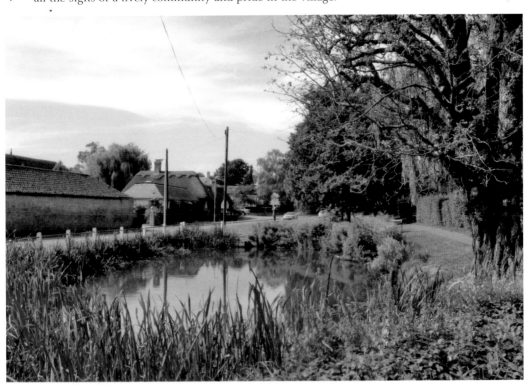

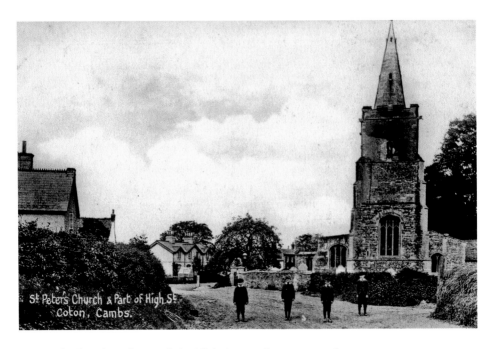

St Peter's Church & Part of High St. Coton, Cambs.

St Peter's Church and Part of the High Street, Coton, c. 1906

'Coton's full of nameless crimes,' says Rupert Brooke. I don't know about that, but it is certainly a rewarding small village to visit, especially around the church. I couldn't get the same view as the Edwardian photographer, because of the trees. I went around to the east end, where there is a better view today, with the old pump and village sign in the foreground. The four boys presumably went to the old school, which can be seen opposite the church.

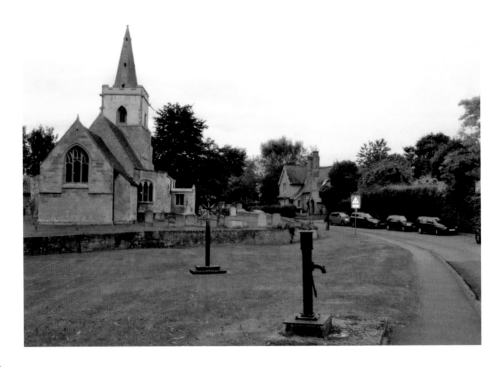

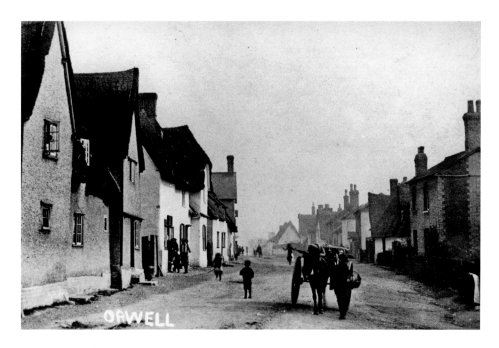

Orwell, *c.* 1906

Again an instantly recognisable section of the main street running through Orwell, apart from the intrusive telephone wires and, of course, the cars. When this photograph was taken the population was between 500 and 600, enough to support three public houses and at least four other beer retailers; today the population is over 1,000 and the Chequers is the only remaining pub. There were carpenters, wheelwrights, harness makers and blacksmiths, all essential for a sustainable rural village. Clunch was quarried at Orwell and forms part of the local building material.

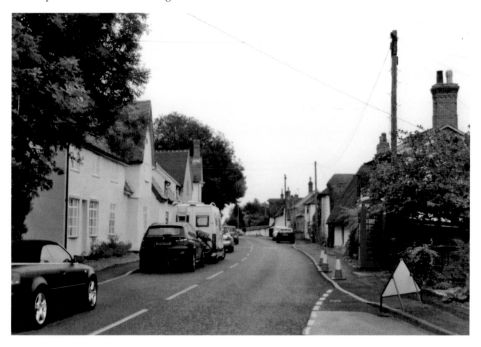

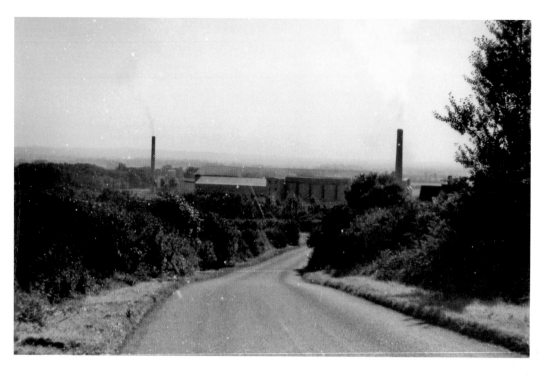

Barrington, c. 1972

Barrington, sitting alongside the East Anglian Heights, was always well known for its brick and cement manufacture. Approaching the village and coming down the slopes of Chapel Hill from Haslingfield, the chimneys of the cement works billowing white smoke always caught the eye, but not this year. I could only see one chimney and that was inactive.

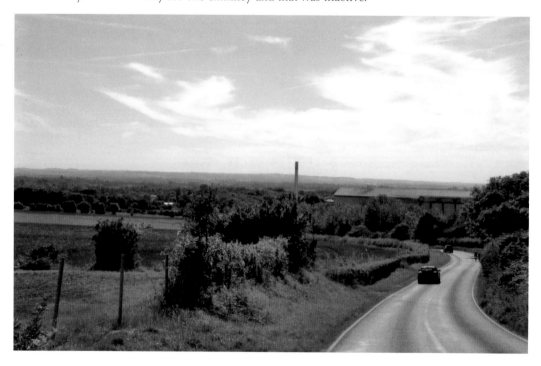

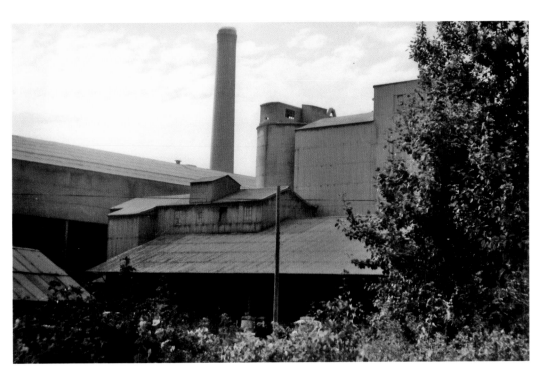

Cement Works, c. 1972

In 2008, after eighty years of cement production on the site, Cemex announced its closure. Subsequently, the company announced that the plant would not be mothballed but there would be a phased demolition. When in full production it had its own 1½-mile railway line connecting with the main line at Foxton. It was the last standard gauge quarry railway working in the UK.

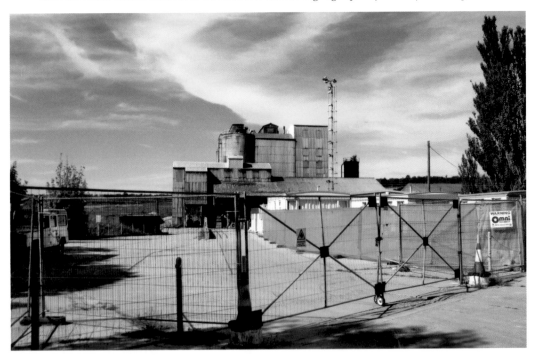

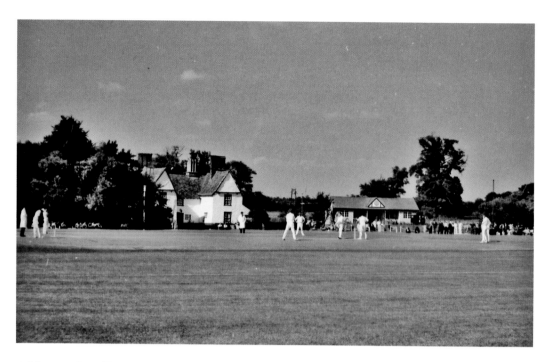

Cricket on the Village Green, Barrington, 1972
This is what I always associate with Barrington: cricket on the green. Barrington has a vast area of village green, with houses overlooking it. What could be more traditional? Taking all my photographs in September, of course, I missed the current season and saw only the football posts ready for the winter sport.

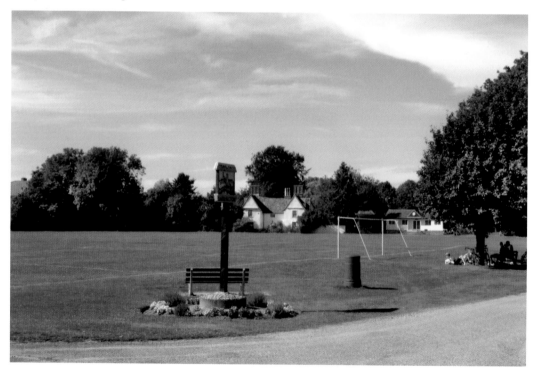

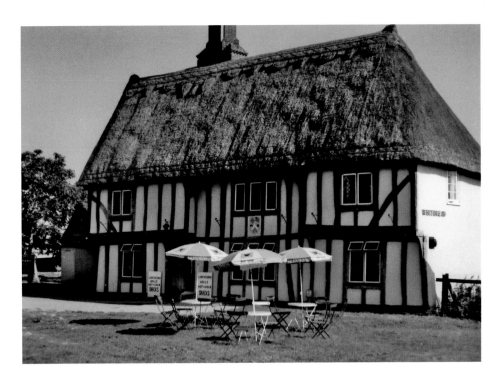

Royal Oak, *c.* **1972**

The sixteenth-century Royal Oak is the last of Barrington's six public houses, occupying a beautiful spot overlooking the green. You can sit outside and contemplate that there are 30 acres of village green in front of you and that it might be, at half a mile long, one of the longest in the country, or you can just sit and enjoy a drink and some food and appreciate the English village and relax and learn to live again.

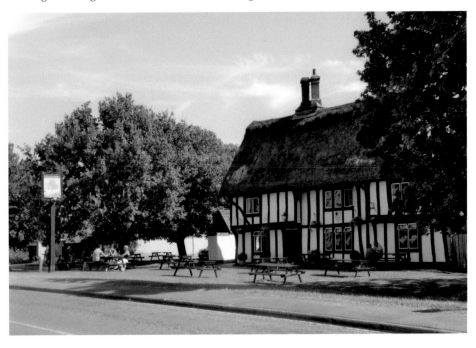

Shepreth Mill, *c.* 1972

Shepreth Mill is on a tributary of the River Rhee, also known as the Cam. The mill was also known as Church Mill. When it was sold in 1919, it was described as a timber mill. It was still in use in the 1950s, but has been a private residence for many years now. On a tight bend in the village, it is quite easy to miss it but it is an attractive, weather-boarded house with a nice mansard roof and little changed over the years.

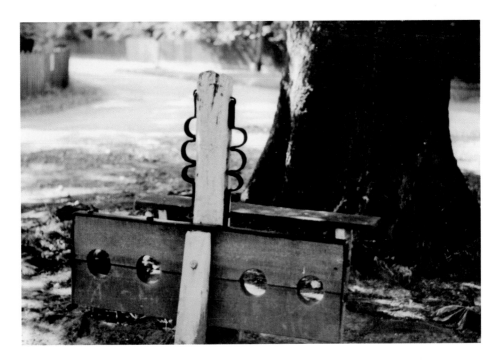

Meldreth Stocks, c. 1972

Meldreth is another pretty village on the River Mel that flows into the Rhee or Cam. Its unusual distinction is having the old village stocks and whipping post on the small Marvell's Green, close to the old manor house, which is now a Scope school for disabled children and adults. The whipping post was erected in 1782 and new stocks in 1833. The village history thinks the stocks were last used in 1860 'for brawling in church'. For those who want to 'bring back the stocks', this is what they looked like.

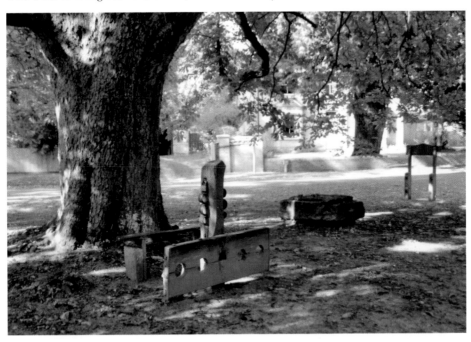

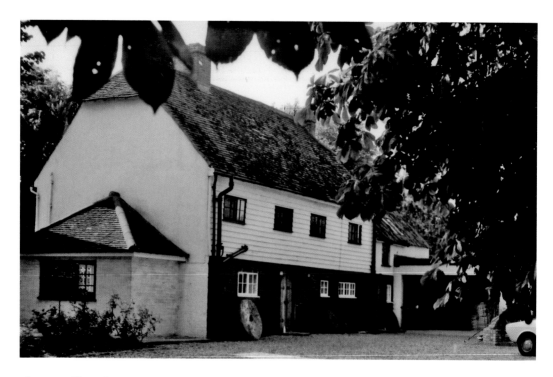

Sheene Mill, Melbourn, _c._ 1972
Meldreth and Melbourn are now separated by the recently opened Melbourn bypass. Sheene Mill was the mill for Sheene Manor and was built in 1851, working until 1929, after which it became a private house. Today Sheene Mill is a high-class hotel and restaurant in a superb setting beside the River Mel. In 2005, the River Mel Restoration Group was formed to improve the biodiversity of this chalk stream.

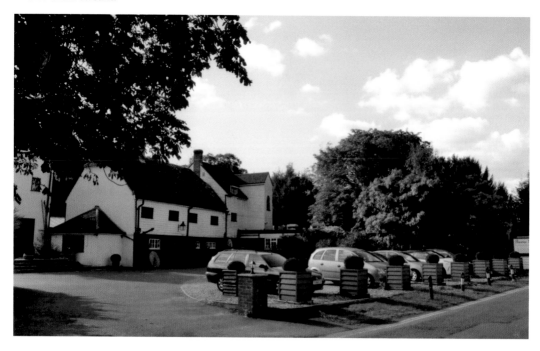

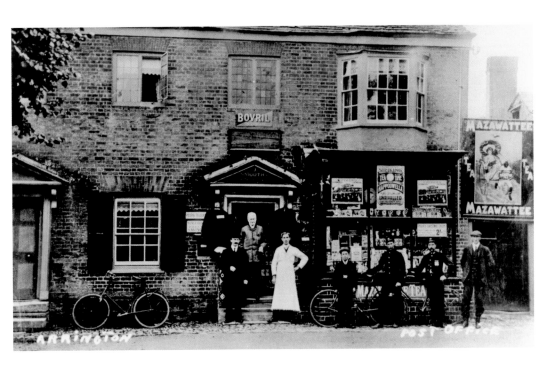

J. Smoothy's General Stores, Arrington, c. 1910

Arrington stands on the old Ermine Street as it cuts its straight Roman line from Royston to Godmanchester. The proud owner and staff stand in the doorway and telegraph men stand beside their bicycles, a reminder of how a few years later families would receive the dreaded news that someone beloved would never return from the fields of Flanders. Advertisements variously proclaim Chivers jam, Happowella's 'striking and unrivalled Ceylon tea', private Christmas cards at two shillings a box, Bovril and Mazawattee tea. What a difference a century makes.

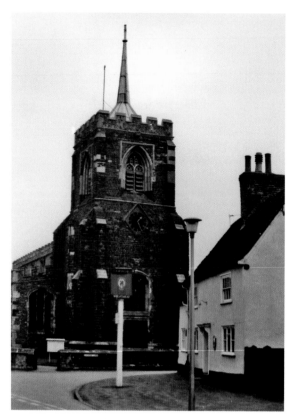

Gamlingay, *c.* 1972
Gamlingay is one of the large old Cambridgeshire villages and once it was of even more significance, but a disastrous fire in 1600 caused it to lose its market to the town of Potton, just over the border in Bedfordshire. Today the population is around 3,500 and the Wheatsheaf public house, next to the church of St Mary the Virgin, is one of only two public houses that survive from the many that were once open.

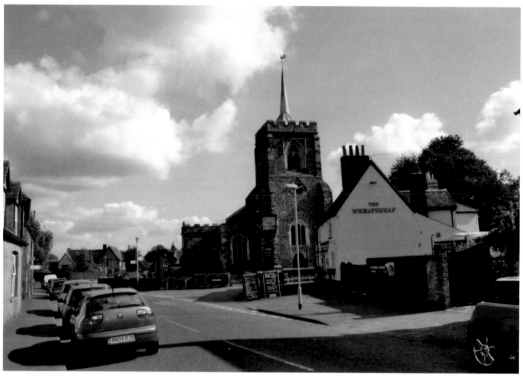

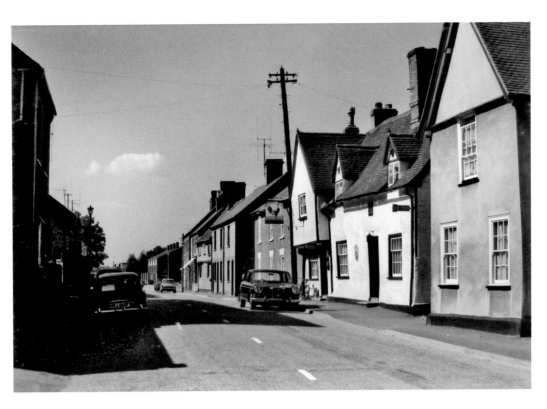

Church Street, c. 1972
Church Street is the busy main street running through the village and again this pretty section of the street appears to have changed little. The other public house, the Cock, can be seen in the centre.

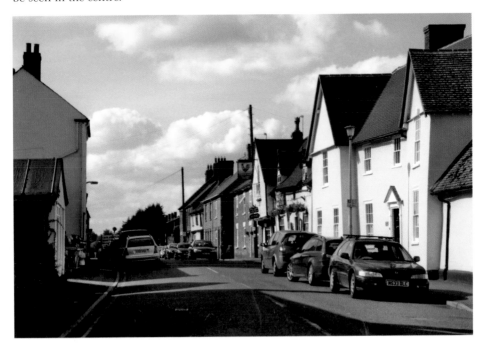

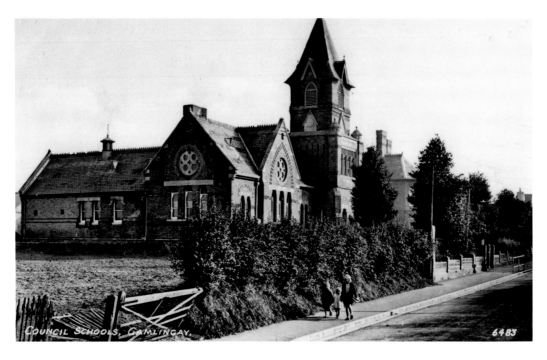

Council Schools, Gamlingay, c. 1955

The old council schools building, opened in Green End in 1877, is still in use today as Gamlingay First School, before pupils transfer to the middle school. In the late 1950s the central bell-tower was removed as it had become unsafe; otherwise, externally the building has changed little over the years.

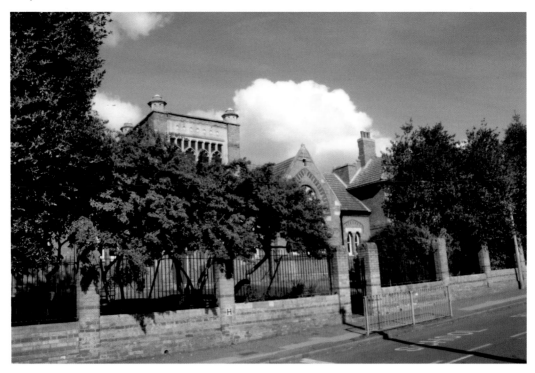

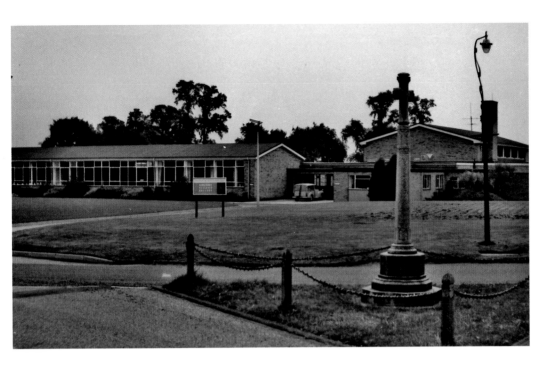

Gamlingay Village College, *c.* 1972

Gamlingay Village College has always been one of the smallest of the county's village colleges. It has experienced some challenging times in recent years and is now a foundation middle school, taking pupils in Years 5, 6, 7 and 8 before most of them transfer over the county border to Stratton Upper School in Bedfordshire. The Cornish granite war memorial erected in 1920 records the names of sixty-five men from the village who died in the First World War; fourteen names were added after the Second World War.

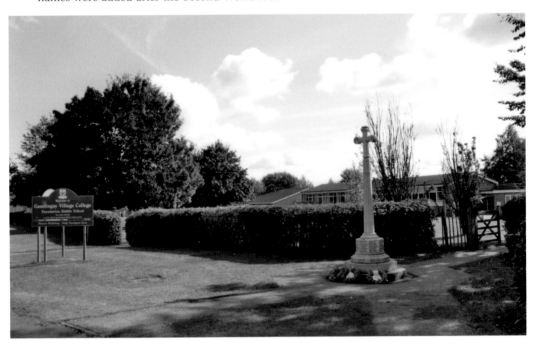

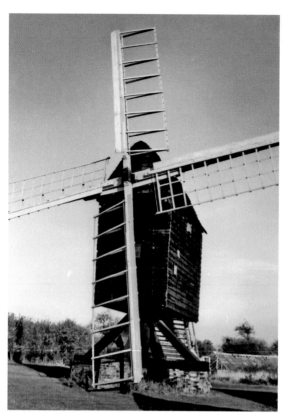

Bourn Post Mill, *c.* 1972
One of the most famous post mills in the county, and probably the country, it lies outside the village of Bourn on the road to Caxton. A mill existed here in 1636, but its working life ended in a gale in 1925, after which it was bought for £45 in 1931 by Lord Bossom and Mr Mansfield Forbes and presented to the Cambridge Preservation Society (now known as Cambridge Past, Present and Future). Restored by C. J. Ison of Histon, it has been kept in good repair, including the replacement of the stocks and sails in 2003. Put simply, it is one of the most wonderful ancient monuments in the county.

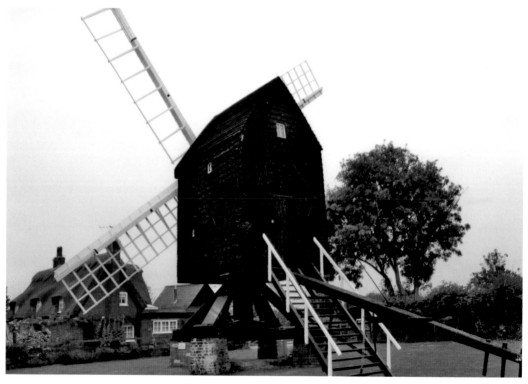

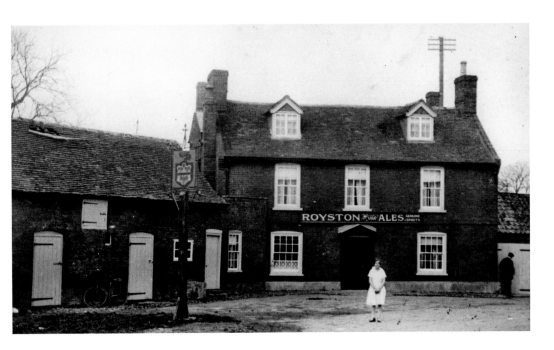

The Leeds Arms, Eltisley, *c.* 1920

I hadn't been in Eltisley for forty years and thought there may be nothing left of the old Leeds Arms, or perhaps it would be a private residence, but I was delighted to find it still there, close to the village green, not far from the old Cambridge to St Neots road. Today it is a Charles Wells House, known as the Eltisley Arms, after it was completely refurbished in 2007 as a restaurant and public house. Eltisley is a beautiful village with a classic village green, cricket pitch and nearby Cade Pavilion. It reminds me of Barrington.

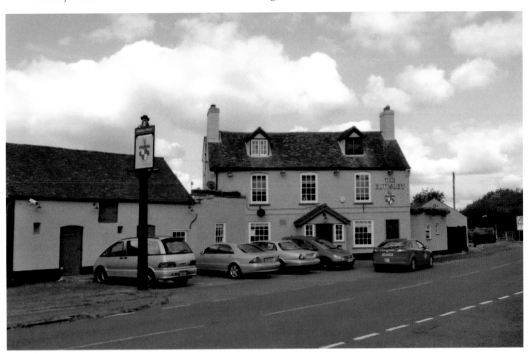

CAXTON GIBBET.

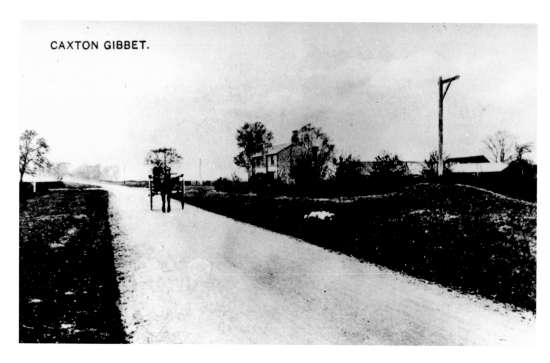

Caxton Gibbet, *c*. 1906 (Inset *c*. 1972)
Where the Ermine Street crossed the A45 Cambridge to St Neots road stands this grim reminder of ancient justice, when highwaymen and other felons were hanged in iron cages until they starved or died from exposure. In the background is the old inn, which eventually became the Yim Wah Chinese restaurant. This was destroyed by fire in 2009. It is likely that a new drive-through restaurant will be built here and hopefully the replica gibbet, which has survived for over a century, will be restored or recreated.

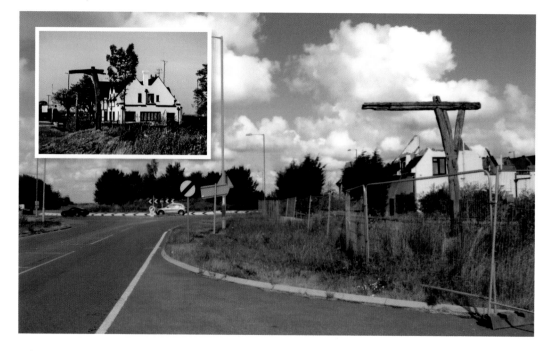

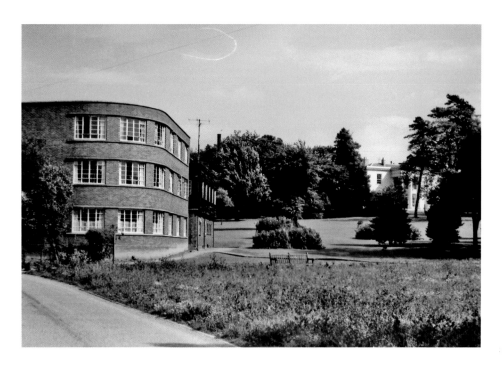

Papworth Hospital, Papworth Everard, c. 1972

Papworth Hospital began as a tuberculosis hospital around Papworth Hall in 1918. The hospital also pioneered independent living for recovering patients, providing work for them, which eventually led to the formation of the Papworth Trust. In 1979, the first successful UK heart transplant was carried out here. With a worldwide reputation, it is likely that this remarkable hospital will relocate to the Cambridge Biomedical Centre next to Addenbrooke's Hospital in Cambridge. Pendrill Court provides a fantastic village hub and there are superb playing fields, along with fine new Trust housing.

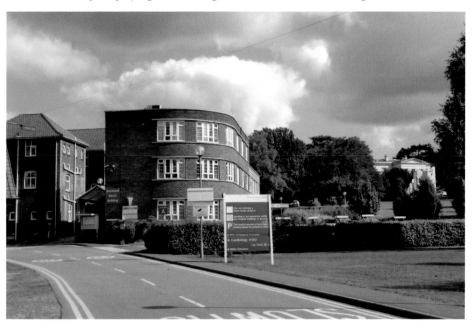

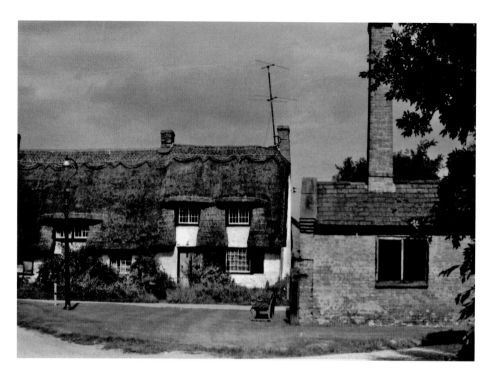

Papworth St Agnes, *c.* 1972

How did I ever find Papworth St Agnes in the first place? There is one narrow lane into this tiny settlement. When I first went there, the population was around forty and it is probably the same now. It was this communal bakehouse built in 1850 that attracted me. The idea of a small community taking it in turns to bake their bread and with the hamlet's water pump at the back of it; it was the ultimate meeting place.

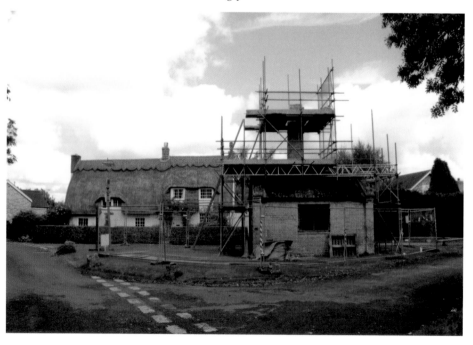

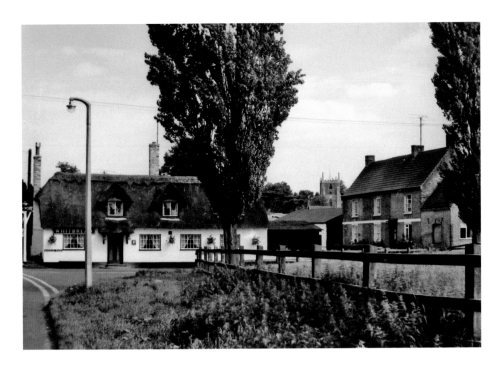

Elsworth, c. 1972

I turned back from the borders of Huntingdonshire into old Cambridgeshire and immediately found this lovely spot in the small village of Elsworth. Again it is a village pub I photographed, which is ironic because in the 1970s I didn't drink at all, but I think I recognised village pubs as a vital part of their communities. It was the Fox & Hounds when I first saw it, and having survived various closures, it is very much back in business as the Poacher.

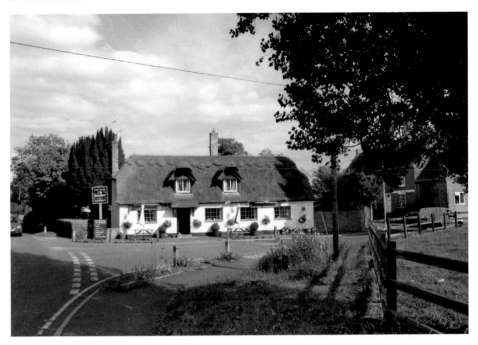

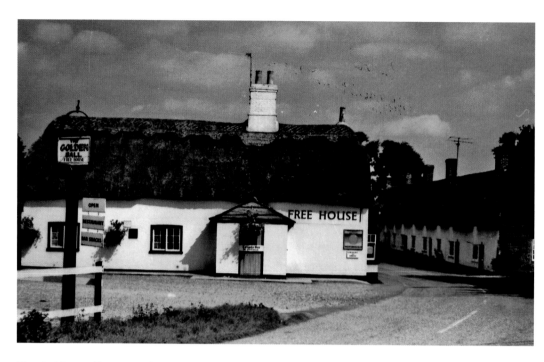

The Golden Ball, Boxworth, *c.* 1972
Another pub, I know, but what a beauty! A sixteenth-century inn, privately owned, just off the A14. It has been sympathetically extended since I first saw it and offers food and accommodation in an eleven-room annexe. While Boxworth is a hamlet of about 100 houses, it is close to the new town of Cambourne and should benefit from the new community that has emerged since I first visited this area.

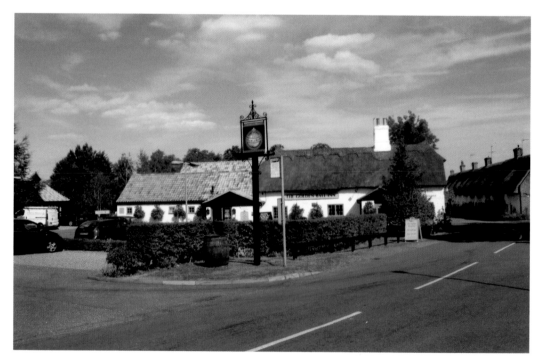

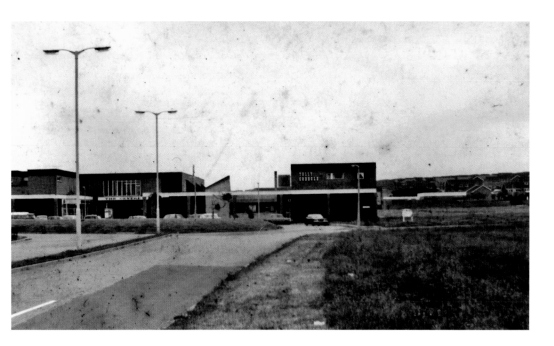

Bar Hill, c. 1972

New settlements at Cambourne already becoming established and a possible new major eco-settlement of 10,000 homes at Northstowe on the old RAF Oakington site make Bar Hill, just off the A14, seem like an olde English village. In fact, after many years of planning, the first residents moved there in 1967 and it developed over some twenty years to a village with a population of around 5,000. There are good facilities, a hotel and golf course, but mostly it is known for its huge Tesco Extra store.

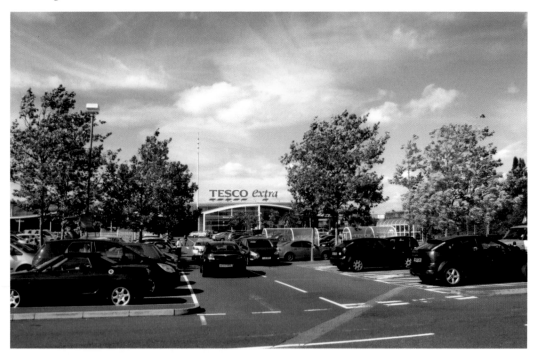

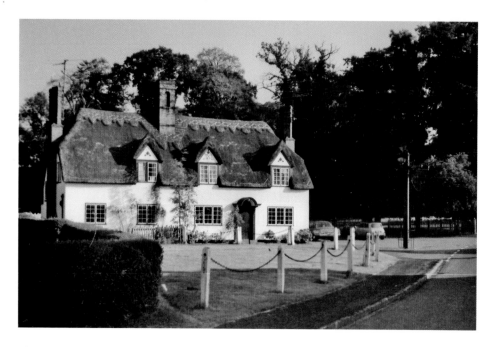

The Three Horseshoes, Madingley, c. 1972

The Three Horseshoes is a popular restaurant in the pretty village of Madingley. Between my two photographs there was a disastrous fire in 1975 and a reconstruction. Madingley is known internationally for its American military cemetery for servicemen in the Second World War, the only one in Britain. Cambridge University donated the land in 1943 and it was formally dedicated in 1956. It is a place of honour and beauty with 3,812 graves and 5,127 names on the Wall of the Missing, a sad reminder of the sacrifice of so many young men from across the world.

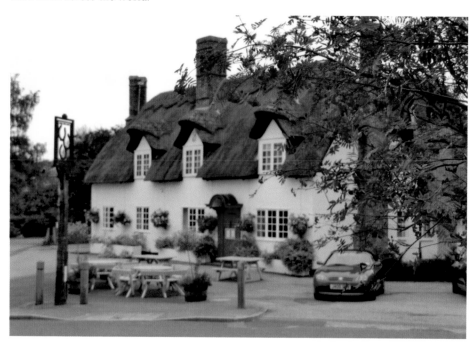

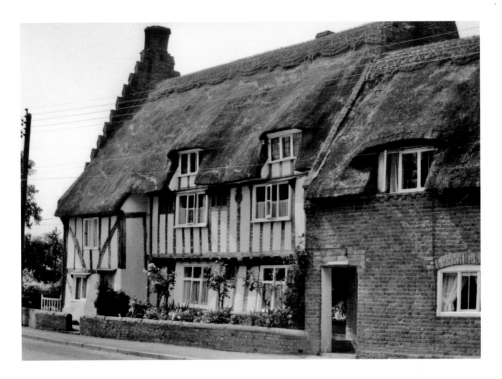

Fen Drayton, *c.* 1972

The busy and much-discussed A14 connects East Anglian ports with the Midlands. It thunders with speeding lorries and has frequent accidents. West of Cambridge, towards Huntingdon, the route follows that of an old Roman road that really skirted the edge of the Fens. Once north of it there is a 'fenland village' feel to many of the settlements, particularly Fen Drayton, which has some fine domestic buildings.

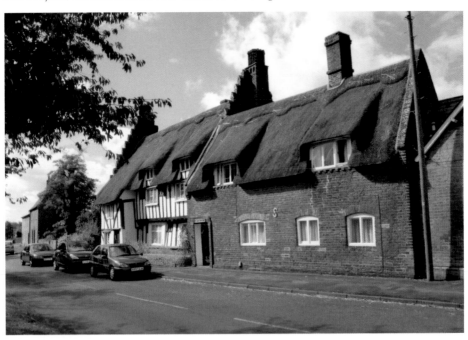

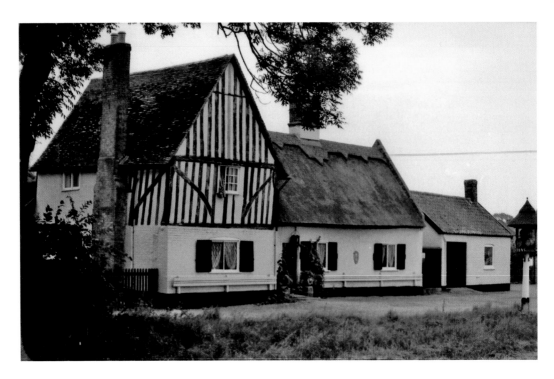

The Three Tuns, Fen Drayton, *c.* 1972
Very much the centre of the village, at a crossroads and where the small stream, now overgrown with rushes and reeds, once took barges to the small inland port of Swavesey, the Three Tuns is a fifteenth-century building of great charm and interest with claims to having been the village Guildhall. It has been recorded as a public house since the eighteenth century.

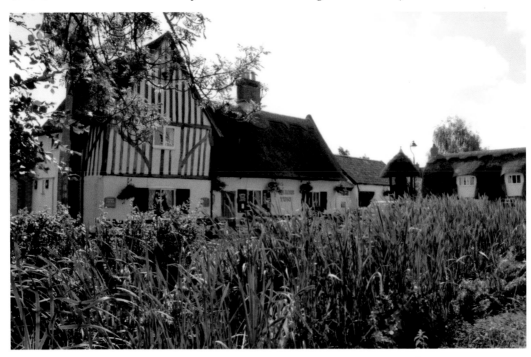

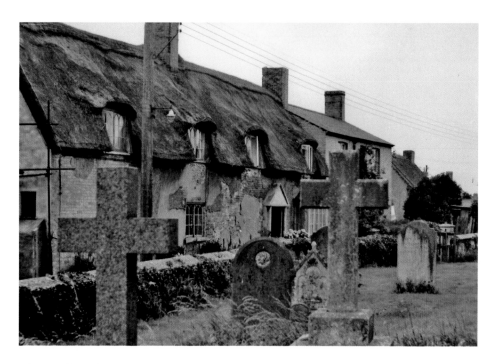

Niet Zonder Arbyt, Fen Drayton, *c.* 1972

I went in search of what I always thought of as the old Dutch cottage opposite the village church. I had photographed the porch carrying the date 1713 and the inscription '*Niet Zonder Arbyt*', linking it to the Dutch drainage engineer Sir Cornelius Vermuyden, who was responsible for much of the seventeenth-century drainage of the Fens. Sadly the old cottage was destroyed by fire in 1974, but the porch was incorporated into the new house. Meaning 'Nothing without Work', the inscription has been adopted for the South Cambridgeshire District Council's crest.

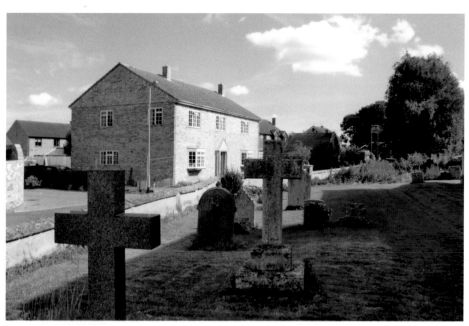

Rampton Green and Pump, *c.* 1972
I was pleased to see on my return to the attractive, small village of Rampton, with its splendid village green and pump, that the 'No Parking' sign was no longer nailed to it. After all, the pump is a Grade II listed building, and so it should be. This was where many of the villagers would meet to collect water from the lower spout but also exchange news. The higher spout was for carts. Some places had dust-laying carts which would refill here, and the water would be sprinkled on the dusty roads to keep the dust down.

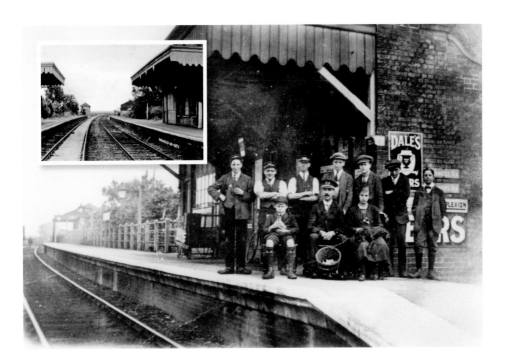

Oakington Station, *c.* 1920

On the Cambridge to St Ives Railway line, opened in 1847, Oakington station at Westwick was conveniently placed to take much of the locally grown market garden and horticultural produce. The line closed to passengers on 3 October 1070 but was still open for goods, particularly gravel, when I was there in 1972 (*inset*). In 2007, the St Ives platform was demolished for the guided busway which, since 2011, has run along the old trackbed. The station buildings had already been converted into a private home.

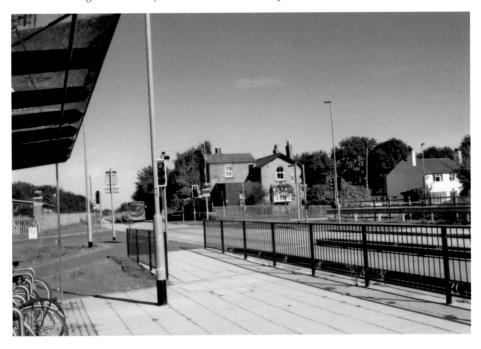

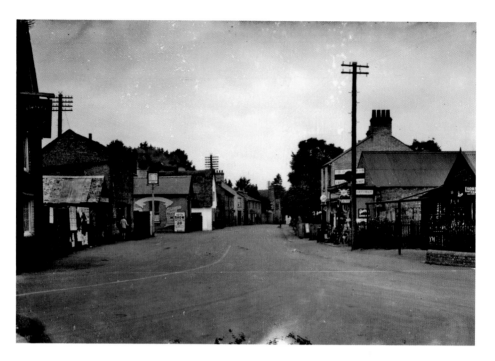

High Street, Histon, c. 1920

A Ted Mott photograph showing the Boot public house on the left and the Barley Mow further down, both still there today on what is a busy road. Histon had a population of around 1,500 at this time, but it has usually been combined with its close neighbour Impington. The two places are so intertwined that they are like one. Today Histon numbers around 4,500, and with Impington around 8,500, making it one of the largest county village settlements.

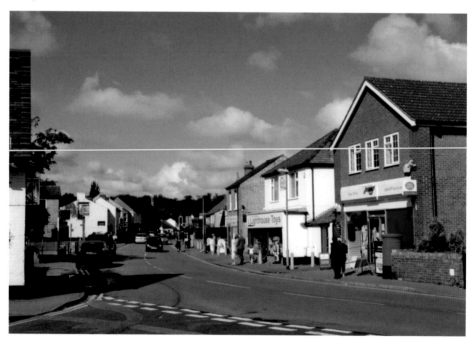

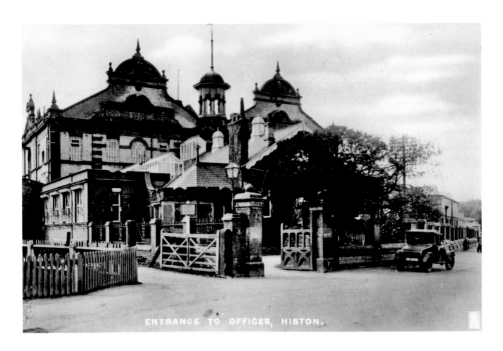

ENTRANCE TO OFFICES, HISTON.

Chivers Factory, Histon, Mid-1920s

The Chivers family began making jam from their own fruit in a barn in Impington in 1873. They were so successful that by 1875 they had built their first factory alongside Histon railway station. Soon, other products like Chivers jellies gave year-round employment for as many as 2,000 workers when this photograph was taken. The Chivers family were enlightened employers and looked after their employees' welfare and recreation. In 1959, Schweppes bought the business. In the 1980s the company relocated to new premises as the whole site became a business park and the old factory was demolished.

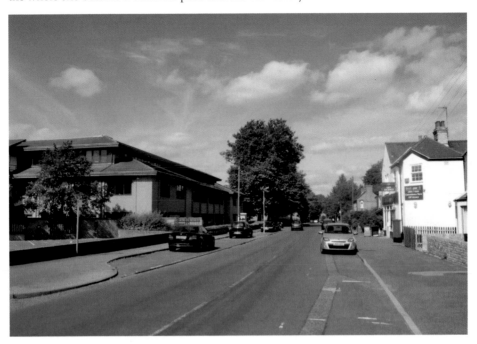

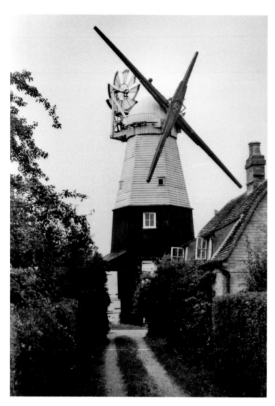

Impington Mill, *c*. 1972
Built on the site of an earlier post mill, this smock mill dates from 1776. In 1903 it was bought by John Chivers and in the 1920s it was driven by an engine until it ceased working in 1930. In 1966, it was sold into private ownership. Pippa and Steve Temple bought the mill in 2000 and began a full restoration, with new sails being fitted in 2007. Today it looks absolutely majestic and the owners hope to have it grinding corn again in the future.

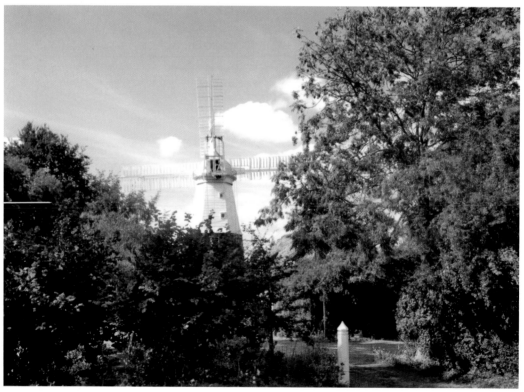

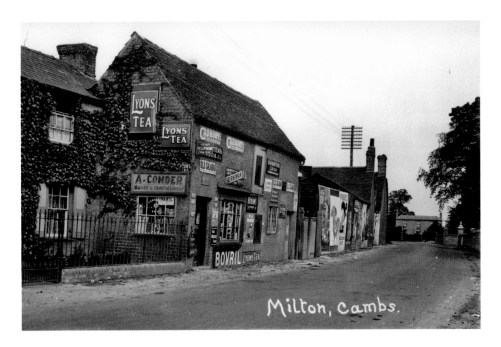

Milton, *c.* 1920

A final Ted Mott photograph and full of interest, showing Arthur Conder's bakers and confectioner's shop at the north end of the High Street. The wonderful enamel signs advertised everything: Lyons tea, Bovril, Cadbury's cocoa, Horniman's tea, Houten's cocoa, Colman's starch, Hudson's soap, Wild Woodbines and Old Calabar dog biscuits and poultry food. Nothing remains today of the old shop, although the family name has been given to a road in a new development.

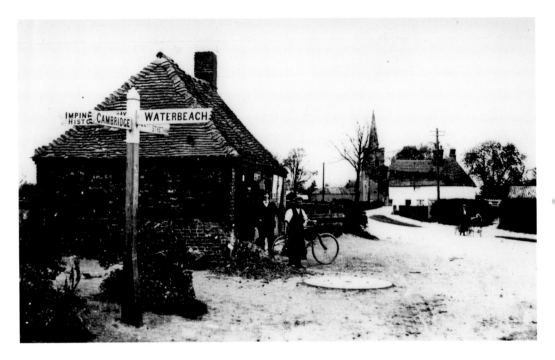

Landbeach, c. 1910

The old crossroads in the centre of historic Landbeach, which has now been mercifully bypassed by the A10 from Ely to Cambridge. The old forge stands in the foreground. The iron hooping plate can be seen in front of it. This was where the hot iron rims were fixed on the large wooden car wheels. Today, the village centre with the adjoining sports field stands where the old smithy once worked. The name Landbeach tells us that we are on the very edge of the old fens.

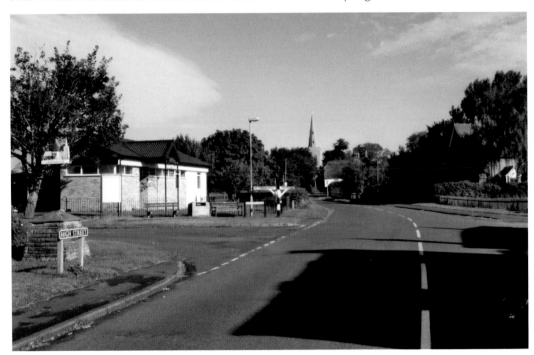

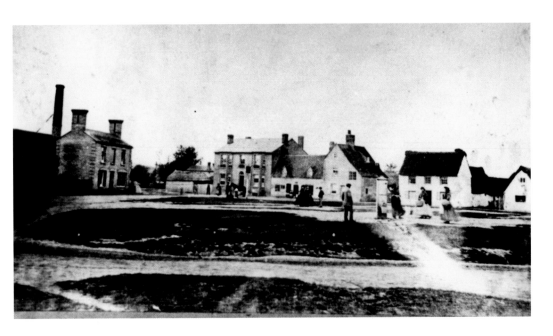

Waterbeach, c. 1900

A view across the village green showing a group of women collecting water from the village pump. A much larger village than Landbeach, Waterbeach has a station on the King's Lynn to London railway line. During the war, Waterbeach had an aerodrome and in recent years this has been the home of the Royal Engineers, but now it looks as if they will leave the base and major development could be on the horizon for this Fen Edge village. The pump is still there, with a low hedge at its back.

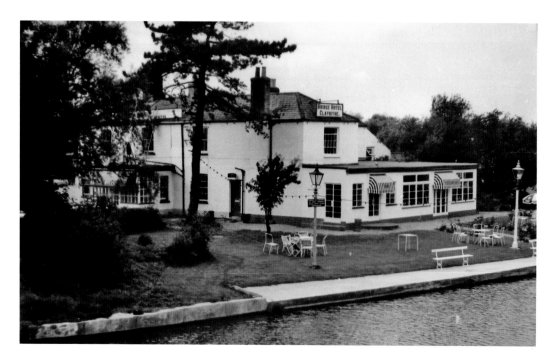

Bridge Hotel, Clayhithe, *c.* 1972

Clayhithe is part of the parish of Horningsea, and opposite the Bridge Hotel on the River Cam is the River Cam Conservators' House, where they have been the navigation authority for the River Cam since 1702. From their workshops at Clayhithe they carry out maintenance and engineering work. *Berky*, their weed harvester, is moored here. The Bridge counts as a Waterbeach public house and has been at this ideal riverside location for some 200 years.

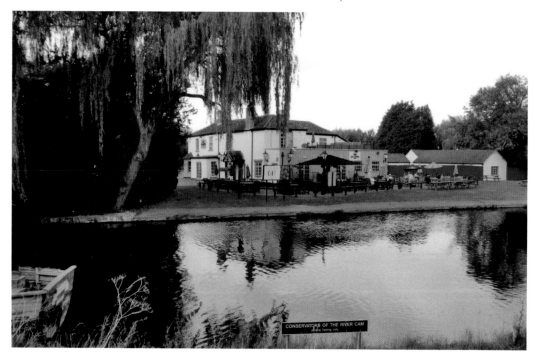

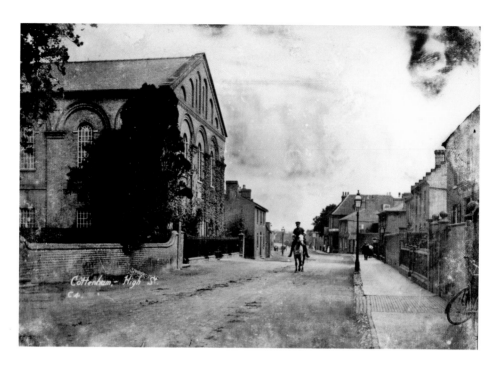

Cottenham, *c.* 1910

Cottenham is like Soham, a linear village with the main road eventually going on to Histon and Cambridge to the south. Around this time, when the population was some 2,500, it was part of a belt of fruit-growing and market-gardening villages. The population today is around 6,000 and it is a busy village with a large village college. North of Cottenham is the edge of the flat fenlands, and we have almost gone full circle.

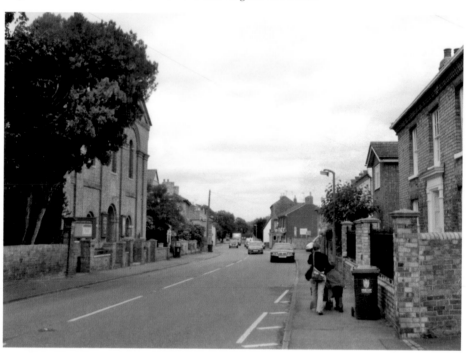

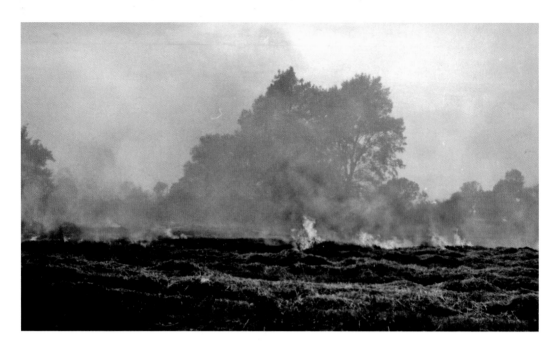

Stubble Burning, *c.* 1972

All my photographs were taken in September this year. The wheat harvest had been gathered in. In some of the fields bales of straw awaited collection, while in others there was yellowy-orange stubble. The cycle of agricultural life was about to begin again. Back in 1972 it would have been a time to close the windows and get the washing in, as the stubble would have been burnt. I remember seeing one farm worker managing a burning field and thinking, 'what age-old skill!' only to see, twenty minutes later, that a whole length of hedge was ablaze. The practice was ended in 1993 and now the fields are ploughed.

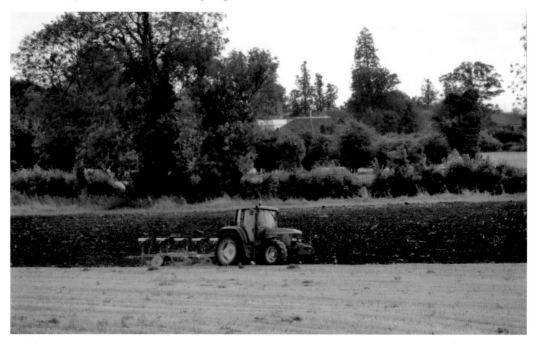